Landscape
Painting
in Oil

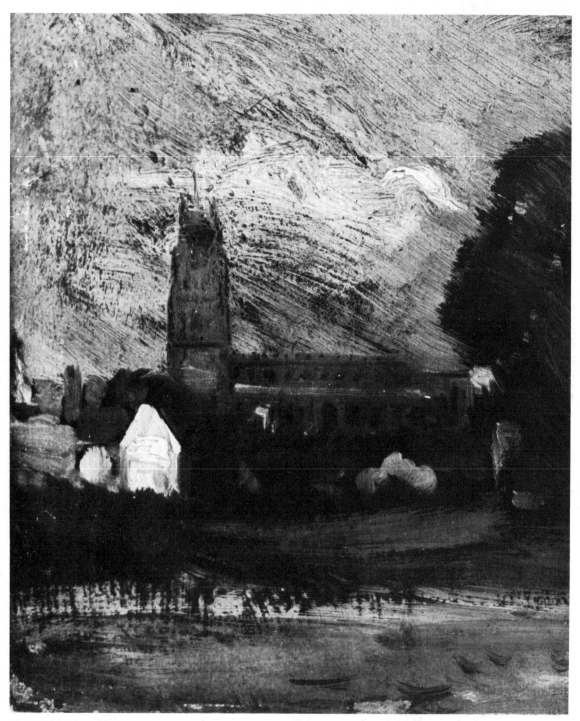

JOHN CONSTABLE 1776–1837
Stoke by Nayland
18 cm × 26 cm (7¼ in. × 10⅜ in.)
Tate Gallery, London
This study shows how strongly contrasted textures of paint can enhance the special character of each element. Constable kept such use of texture under masterly control. Without control, and unguided by structural demands, wilful texture-making is more likely to imprison the subject than reveal it

Landscape Painting in Oil

Colin Hayes

B T Batsford Limited London

© .Colin Hayes 1980
First published 1980
ISBN 0 7134 0596 1

Filmset in Monophoto Times New Roman by
Servis Filmsetting Limited, Manchester
Printed in Great Britain by
The Anchor Press Ltd,
Tiptree, Essex
for the publishers
B T Batsford Limited
4 Fitzhardinge Street
London W1H 0AH

Contents

Acknowledgment

The author and publishers thank individuals and galleries for their permission to include the following illustrations in this book:

ADAGP for page 89
Birmingham Museums and Art Gallery for page 48
Boymans Museum, Rotterdam for pages 34 and 88
Bury Art Gallery for page 31
Courtauld Institute, London for page 61
The Fine Art Society for page 94
Indianapolis Museum of Art for the colour plate facing page 73
Ipswich Borough Council for page 31
The Louvre, Paris for pages 24 and 72
Manchester City Art Gallery for page 49
Musée Marmottan, Paris for page 60
Musée de Rouen for page 32
The National Gallery, London for pages 10, 19, 84, 86
The National Galleries of Scotland for page 96 and the facing colour plate
The National Museum of Wales for page 26
Rochdale Art Gallery for page 100
Royal Academy of Arts, London for page 36
Royal Albert Memorial Museum, Exeter for page 62
SPADEM for pages 98 and 99
The Tate Gallery, London, for frontispiece and pages 44, 46, 50, 52, 89, 98
Victoria and Albert Museum, London for pages 68 and 70

Introduction

This book is predominantly about the kinds of landscape which derive from observation. It is concerned to be of help to painters who attempt to express something of what they see before them in a particular place at a particular time.

The difference between the 'observed' and the 'imaginary' is not clear cut, but it may be remembered that what is called 'imaginary' landscape can sometimes be a generalized amalgam of scenic memories couched in the visions and experiences of other painters. Such amalgams are likely to be compounds of what the artist already knows or has culled from the knowledge of others: they are preconceptions.

The landscape of direct visual experience has the particular quality of bringing the painter face to face with the unexpected. However well-known its countryside, however familiar its *genius loci*, an actual subject will contain shapes the artist has not seen before, relationships which cannot quite have been anticipated, qualities which are beyond preconception.

Since we are to occupy ourselves principally with observed landscape it is worth recalling its antecedents. For landscape painting has not always been concerned with this expression of specific natural appearances.

References to landscape in medieval art were largely symbolic in purpose. Even from the Renaissance until the late eighteenth century, most painters who used landscape themes did so from an obsession with classical ideal or romantic drama. Certainly they often used observation as a working basis for their inventions and fantasies; the drawings of Titian, Claude, Rubens and Rembrandt are examples of acute study. Even in paintings reference can be found to actual places. But the idea of capturing in paint the special quality of open-air light, of 'out-of-doors', seems missing, or is very rare. Some of the Dutch seventeenth-

century painters, Ruisdael among them, came near to this, but their rendering of space and light still depended extensively on Baroque studio devices.

Among those who led the way out of the studio door, English artists have a fair claim to be in the vanguard. Watercolourists such as J R Cozens and the short-lived Thomas Girtin were among the first to make observed landscape a central preoccupation of their art. Turner and Constable following them, were perhaps the first to take the expressive capacities of oil paint truly into the open air. Constable in particular did more than any other painter to cultivate our open-air vision, and the immense popularity of his reproductions shows how even now his vision of landscape is widely accepted as a kind of norm. Turner's daring in rendering light almost to the apparent exclusion of form released our eyes from the bonds of picturesque and 'acceptable' subject matter.

Of course the Impressionists, Post-Impressionists, Fauves, and many others have supplemented and enriched our vision since the days of Constable and Turner; so much that it might easily be felt that all has been said about landscape, and that the time has come to turn our backs on that which can be observed. Certainly critical attention is hardly focussed on landscape, and we may be absorbed by valid artistic expression which has nothing to do with observation. Nevertheless, once our powers of looking have been opened up by masters, they are not easily closed again by a critical climate.

Perhaps it is a special property of the landscape masters to have said so much about the subject without closing the door on it. The material is inexhaustible, and we need not pessimistically assume that there is less vision in the world than there was.

Painters can still look, if they wish, and find something of their own to contribute to what they see. Landscape painting has no need to be apologetic about its existence, and this book has assumed its validity.

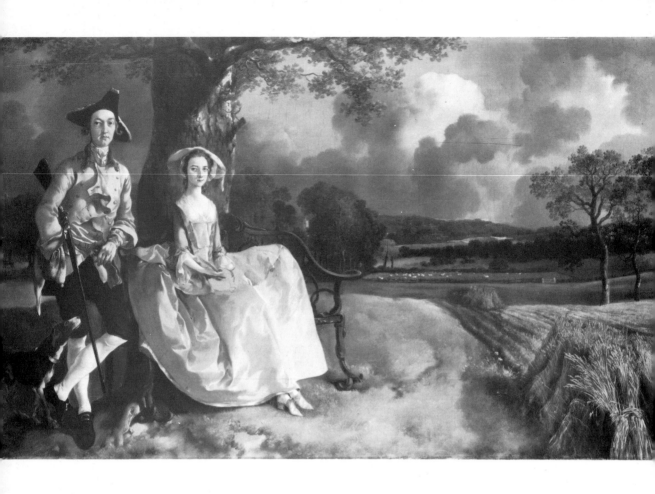

THOMAS GAINSBOROUGH 1727–88
Mr and Mrs Andrews c.1748
Oil on Canvas 70 cm × 119 cm (27½ × in. × 47 in.)
National Gallery, London
This early painting by Gainsborough is of course
essentially a double portrait of a newly married
couple, but it shows how well also the arts of
portraiture and landscape can be married. It is a
difficult undertaking, and we can see so many
examples of the genre in which studio and out-door
tonality remain unhappily at odds.

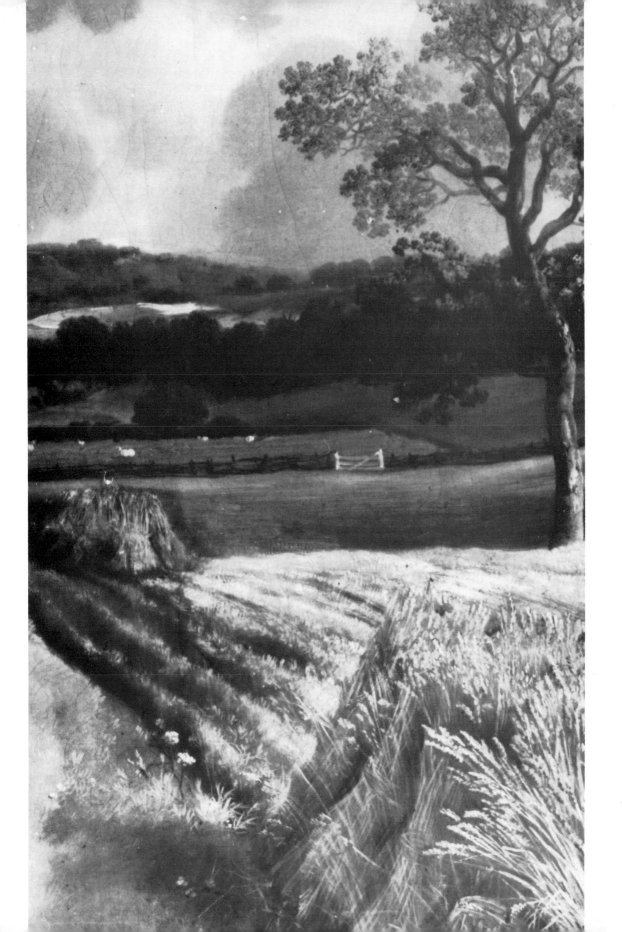

The Structure
of Landscape

The structure of a room, or of a still life on a table is not too difficult to understand. To draw and paint these things is a demanding problem but to know their dimensions need not be. Things that we draw and paint indoors are usually within a few paces of our touch, and we can see, if we cannot so easily render graphically, the distance of one thing from another. Normally-sighted people possess binocular vision which enables them to assess, by the reflex stereoscopic working of the eyes, the third dimension to the limits of distance of most indoor subject matter. If all else fails we can even take a tape measure to things.

We cannot take a tape measure to a landscape. A topographical surveyor might; though possessing more subtle skills and instruments, he does so no more than he must. The landscape painter, without benefit of trigonometry and theodolite, cannot directly measure his subject even to the extent that he could roughly estimate the spatial dimensions of a still life or an interior. Even the natural benefits of stereoscopic vision operate only within a limited distance of foreground.

Direct linear measurement of depth in a scientific sense is something for which the landscape painter seems unequipped: much of the lie of the land before him may in any case be hidden from view, and it might seem that except by reference to a large scale contour map of the neighbourhood, he can give nothing except a surface rendering of the outlines and colour values visible to him.

Nevertheless, it is possible for a painter to sense and express the structure of landscape in his own ways. Sheer familiarity with a district is one way of 'reading' a landscape, and can be more valuable than a map. The two most firmly structural masters of observed landscape, Constable and Cézanne, had each trodden the ground of his favourite subject-matter since childhood.

Even without this special familiarity, a painter may find explanations in the resources of scale, atmospheric recession, topographical character and simply common sense.

Linear factors
To start with, let us leave for future consideration questions of colour, light, tone and atmosphere. Are there any guidelines which will help us towards a linear sense of landscape structure? Linear factors are those consisting of edges, intervals, points and proportions.

What can we infer from such factors about the lie of the land without being geologists? Common sense tells us some things. However deceptive appearances may be, we can remind ourselves that water does not flow uphill, and that a descending river bed which disappears behind a foreground obstruction cannot be ascending when it reappears on the other side. Still water lies in a horizontal plane; the far shore of a lake or a pond lies at the same level as the near one. Suppose that we are in a valley and that the top of a foreground tree occupies a higher place in the skyline than the peak of a distant mountain. Common sense tells us that the peak is in fact at a higher altitude. It does not take much practice to estimate a point in the distance at one's own eye level; the horizon runs through this point, and again common sense will then tell us that what lies above or below the horizon also lies above or below ourselves. (We must remember, of course, that the 'horizon' does not mean the visible skyline.) Such things are obvious enough; others less obvious.

Let us notice a few points about linear scale, for while this is usually one of the principal factors by which we sense distance, scale can be deceptive.

Linear scale
We all know that when objects of like size process into the distance they appear to get smaller. Let us look in a very simple diagrammatic way at how this apparent reduction relates to distance. We need not worry ourselves about theories of arithmetical and geometrical progression: all we need is a ruler, paper and pencil.

Take first the case of vertical scale, that is, of the vertical heights of objects. These objects may be of any kind, trees, houses, hills, poles: but let us take the simplest case of a series of objects all of the same height.

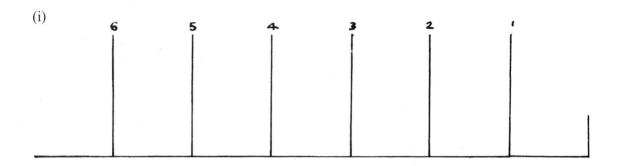

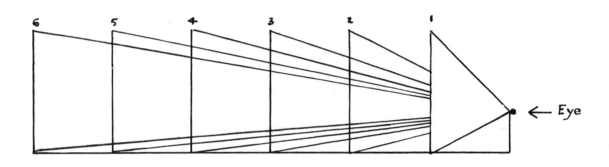

← Eye

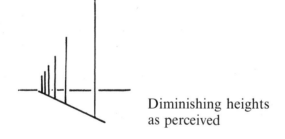

Diminishing heights
as perceived

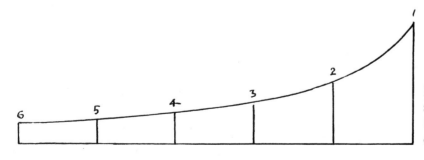

Diminishing heights
spaced along actual
intervals between
each pole

Draw a horizontal line and mark it out at, say, six equal intervals. Leave one end, and raise verticals of equal height from the other intervals, as in diagram (i). The horizontal line represents a stretch of flat straight road, the vertical lines are telegraph poles. Now raise a shorter vertical at the end you have left: the top of this line is your eye. Draw lines from the eye point to the top and bottom of the first pole. This is your view of this first pole. Now do the same thing for the next pole. This second pair of viewing lines will cut the first pole so the second pole appears about half as high; reasonably, since it is at twice the distance. But do the same thing for the third pole and it will seem nearly two thirds as high as the second pole. Again, the fourth pole will seem more than two thirds the height of the third pole. And so on.

In other words, scale does not diminish equally with distance. The more that like objects retreat at equal intervals from your eye, the less is the apparent difference in their scales.

(ii)

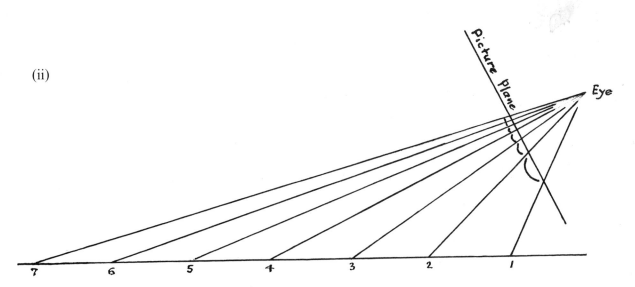

This is also true of receding horizontal intervals, as diagram (ii) will show. In this diagram I have introduced a tilted line in front of the eye to represent the actual picture surface, which we might think of as a sheet of glass on which we are tracing. (You can add this in diagram (i) if you like.)

Draw lines from the eye to points 1, 2, 3, 4, 5, 6, etc, placed at equal receding intervals. We see that these intervals projected onto the picture surface (sheet of glass), start by appearing to diminish rapidly: but the diminutions become progressively less contrasted as the points depart from the eye.

These diagrams may seem a ponderous way of pointing out what seems clear enough once you have drawn them: but as with all things in drawing, it is better to prove a given rule to yourself by experiment, rather than take it on trust. The experiments are worth while because the truths* of these geometrical diagrams may be extended as a general application to other phenomena arising from only approximately comparable dimensions and intervals.

For instance, a sloping wood in the foreground will reveal a scene of sharply diminishing tree scales: a similar wood on a distant similar slope will appear to be bunched up, its furthest trees hardly smaller in appearance than its nearest. Thus we can be deceived into supposing a distant facing slope to be much steeper than it actually is and if we do not understand the relation between scale and distance we may have difficulty in understanding how this slope can relate to the surrounding landscape structure.

Another instance is that of the mountain village which appears from a distance to be almost plastered against a cliff face: only as we enter it do we discover it to be built on a negotiable incline. Of course we must not let rules and guides to observation make us sceptical towards the exceptional or blind us to the unexpected; some mountain villages really are almost plastered to cliff faces.

However, all the above means that, in general, departing intervals in a linear sense become progressively less revealing and informative about real comparisons of depth as they recede into the distance.

Such considerations are so far purely linear, and it will be necessary at a later stage to relate what I have said about scale and interval to the matter of linear perspective. But perspective systems are not in themselves structure, only methods of expressing structure. For the moment let us remain with more basic linear considerations of the structure of landscape.

* Not quite so true as they have been made to look here, since the projection of the way we see onto a flat surface involves some distortion of natural vision; but more of this in the section on Perspective. These distortions do not invalidate the point now made.

Foundations

We have seen that some things are a matter of common sense, that apparent scale in interval proceeds according to visual rules which can both inform and deceive. Are landscapes subject to any other rules of a linear nature?

One factor may be taken as a useful structural assumption rather than a rule, and it involves our asking a question which is often overlooked. We assume that trees grow out of the ground, and that houses are built on land; this is visibly evident. 'Roots', 'foundations', 'ground level', are expressions of everyday use. A structural drawing of a house might naturally be expected to make some reference to the ground on which it is built and might even imply the existence of foundations. But what is landscape built on? What are its foundations and from what does it grow? It could be said that it simply stands on more of itself, down to the centre of the earth, but this is not very helpful to the landscape painter. It may be said that all but the surface weathering and accretions of landscape is ordered by its geological structure; this is certainly true, but it implies a degree of specialist knowledge.

In the meantime we may make an assumption about the foundations of landscape which, although artificial, can be of use in many circumstances.

And here we may remember the map-maker, who since he must refer all the heights he has measured in the field to some governing datum point, refers them to 'sea level'. Now a landscape painter need not do this (unless the sea features in his subject), but he may find it very useful to invent his own 'plane of reference'. He may, that is, liken his landscape to a vast still-life, where all the disparate objects in their complex relationships are ultimately supported on the surface of a table.

A landscape may be thought of as supported, as a house is supported, on a flat surface under its own lowest level. This level will not necessarily be the lowest visible level, but rather the lowest which the painter must sense 'supports' his entire subject. This surface then becomes an invisible plane to which all the visible masses and surfaces can be related.

This feeling for horizontal foundation is of more use to some than others. An evocation of atmospheric fragility may wish to avoid the very sense of weight and firm relationship which foundations give. But where weight and structure are sought, where an artist feels it necessary that a landscape might seem able to support the buildings which lie on it, then the idea of growth from even an assumed base may help towards an expression of this needed strength. A model of this assumed base is the table upon

which a sand-table landscape is made.

A painting which needs this feeling of underlying solidity and support, but which lacks it, can only too easily make a landscape look like the flabby surface of an almost collapsed balloon.

Surface forms: natural and man-made

What is true of the land itself (that weight and mass require foundations) is equally true of the things on it, natural or man-made. Trees and houses which grow or are built out of the ground are structural extensions of that ground. They must not be made to look as though they have merely been placed on a landscape like models on a sand-table. When the form of a hill must be described by the trees covering it, then a sense of the underlying contours which support them must be grasped.

An individual tree has roots which must be felt under the surface. There must be a sense that a house has foundations or it may seem to have merely dimension and no weight. All forms built on or growing from the ground have visible or implied verticals and the points where these verticals meet the ground must be discovered: indeed they not only meet but enter the ground. In the work of great landscape painters, especially in their drawings, it is often possible to see where the verticals of structures have been emphasised and such horizontals as might cut the structures off at ground level have been minimized.

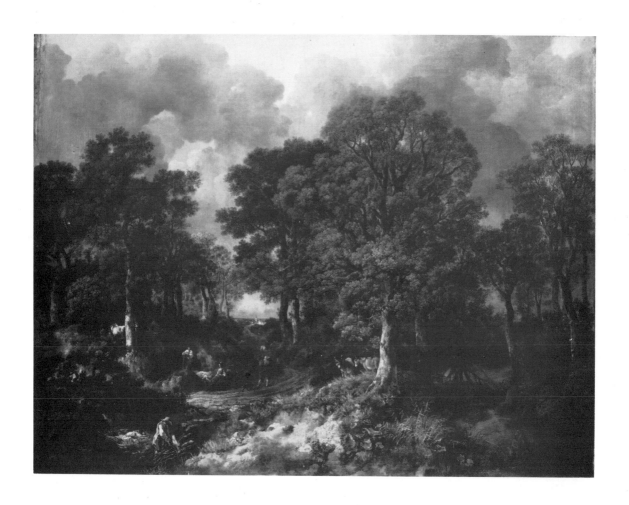

THOMAS GAINSBOROUGH 1727–88
Cornard Wood, 1748
Oil on Canvas 122 cm × 155 cm (48 in. × 61 in.)
National Gallery, London
Most of Gainsborough's landscapes, apart from his
fine direct drawings, are an amalgam of the invented
and the observed. In the conventions of his forms, in
his placing of accents and in the compositional
ordering of his masses he adapted tradition. But as
Cornard Wood shows, he had a sense of place and a
feeling for the tonal unity of nature, which lift his
landscapes far above convention. He commanded the
admiration (not lightly given) of Constable, who
recalled of a favourite Gainsborough landscape, 'I
cannot think of it even now without tears in my eyes'

Cornard Wood, details

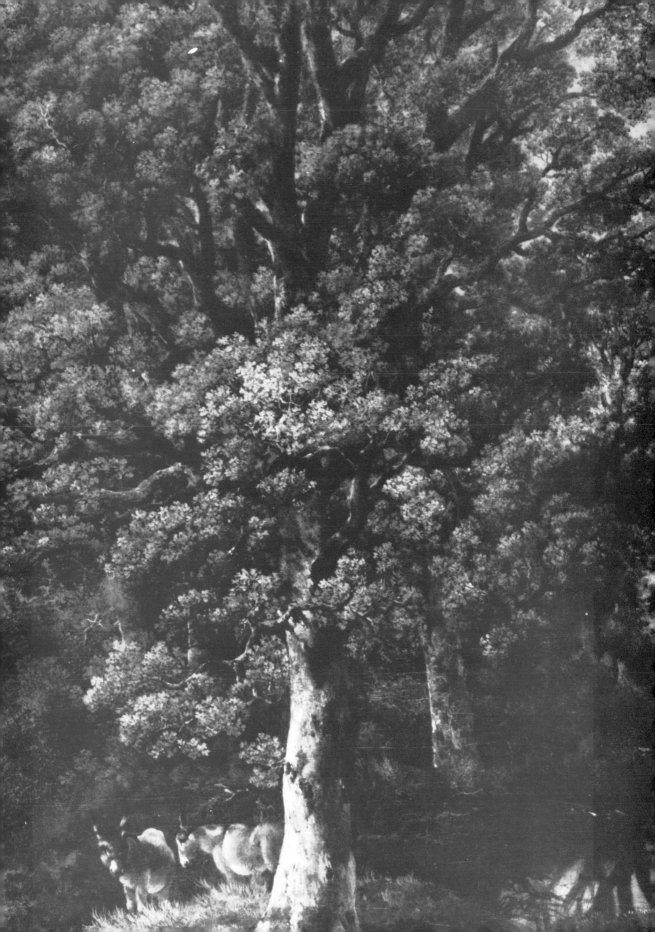

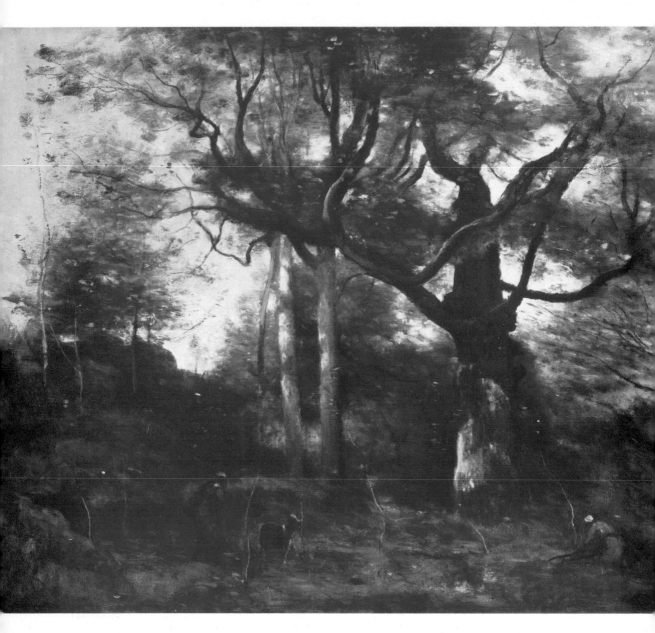

CAMILLE COROT 1796–1875
Fontainebleau, Les chênes du Mont Ussy, 1873
Oil on Canvas 49 cm × 59 cm (19½ in. × 23½ in.)
Later Corot landscapes tend to suffer critical
comparison with his own earlier and more classically
severe works. He came to adopt, as here a 'feathering'
shorthand for finely placed intervals and a sense of
contrasting forms. The French painters of this Realist
period knew well that landscape paintings would not
make themselves mindlessly: nevertheless they stood
against studio contrivance and the grandness of
design summoned by Corot derives less from wilful
rearrangement than from a thoroughly pictorial
choice of motif.

22

PAUL CÉZANNE 1839–1906
Pont de Maincy 1882
Oil on Canvas 59 cm × 70 cm (23¼ in. × 28¼ in.)
Louvre, Paris
Any landscape painter who has not seen this work,
and who finds himself in Paris, would do well to
head for it. It is a masterpiece of the language of
painting; there are no 'literal' marks, but all that is
necessary to the idea is described. For the landscape
painter in particular it is an object lesson in the
discovery of a subject. There is nothing particularly
picturesque or dramatic here in its elements (no
Mont de Ste Victoire), yet the result is pictorial
drama of the first order

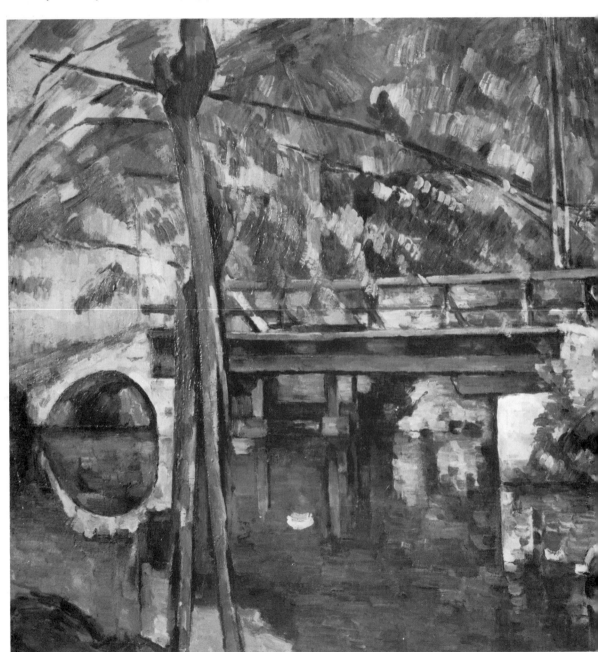

24

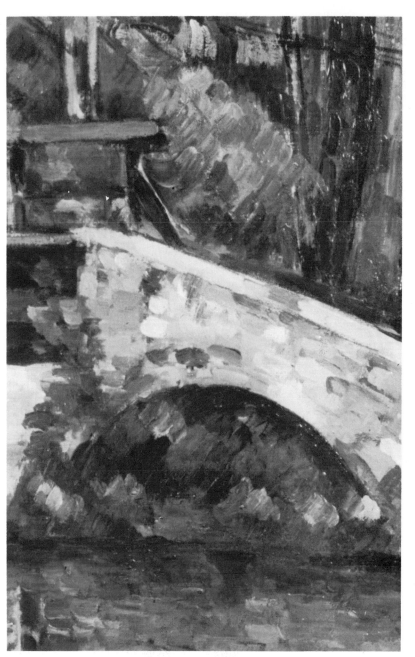

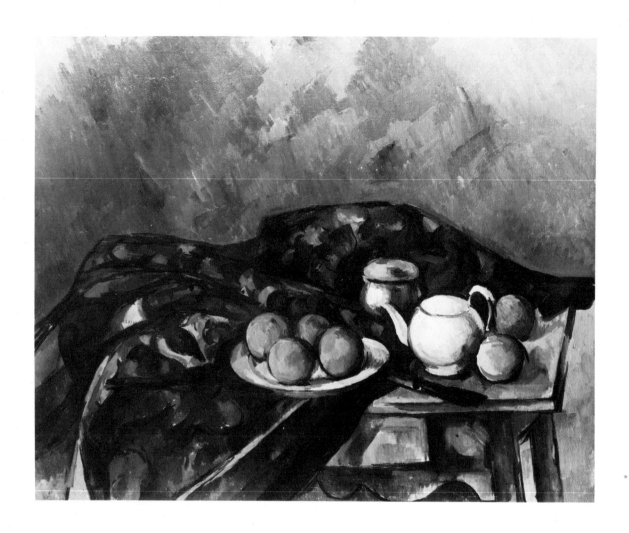

CÉZANNE
Still Life with a Teapot
Oil on Canvas 58 cm × 72 cm (23 in. × 28½ in.)
National Museum of Wales, Cardiff
The inclusion of a Still Life in a book on landscape
may seem puzzling but I bring this painting to the
reader's attention to show how close in some ways
may be the affinity between the two subject matters.
Cézanne in particular often demonstrates how a still
life can within its small physical limits present some
of the formal problems which face the landscape
painter. There is a spatial analogy between
background and sky, between draping and hill forms,
between fruit and jugs, and trees and buildings. The
support of the still life objects by an underlying
surface is much more readily grasped than that of
landscape features and the possibilities of design
inherent in the subject often show themselves more
immediately. A landscape painter may profitably turn
aside sometimes to still life to clarify persistent
problems of structure

Subject Matter

In a sense, it is presumptious to write about landscape
subject matter, except to say that it should be anything the
individual painter decides. This is true, and there might
seem nothing more to say on the matter. But inexperienced
painters, nevertheless, can fall into traps in selecting their
subjects. First of these, perhaps, is the common tendency of
the beginner not to distinguish his own subject matter from
that of others. To be influenced by the masters of landscape
is inevitable and even necessary; to hunt about for a scene
which looks as nearly as possible like one of their paintings
is not inevitable and not probably even beneficial.

The masters drew and painted things which arrested their
attention and sometimes, as with Monet and Cézanne,
subjects which continued to absorb them over long periods.
It is not usually enough that your subject matter should
have arrested and absorbed someone else, however eminent;
it should arrest and absorb *you*. It is for the same reason
that motifs which look, in a more general way, 'picturesque'
should be regarded with some caution. The picturesque
landscape is that which one fashion or another considers to
be a suitable subject for landscape painting, and you may
well be noticing such subjects through the eyes of fashion
rather than through your own. Classical ruins (often a
conventional exaggeration of the real thing) were a prime
picturesque motif of the eighteenth century. The rustic
scene with its cottages and village churches which followed,
in turn gave way to Impressionist suburbia. Industrial
social realism with its pit heads, steel plants and cooling
towers may today be the nearest thing to an acceptable
picturesque. To an extent, one generation's revolt against
the picturesque becomes in itself the picturesque of the
next. There is no reason why we should not paint cottages
or cooling towers if we feel deeply that we have something
of our own to say about them: but we will be heading for

the banal if we use such subjects only because we sense that they will meet with approval.

More contentious a subject matter is that which, whether acceptably picturesque or not, is in itself already a work of art. Fine architecture and great statues are inviting things, but how much can we say about them that has not already been said by the architect or the sculptor?

It need not be a bad thing for the novice (or the old hand) to attempt these subjects. In former times it was the standard art school practice that a student would lead up to life drawing with the study of classical casts: the theory was that the clarifying of forms by the sculptor would help the student to recognize their more elusive presence in the human figure. It may be that some study of 'ready-made' design in the open-air can in a similar way help the student towards identifying the design that lies behind the often highly elusive forms of natural landscape. But such subjects are usually at their most valuable as matters of study, not as substitutes for the development of our personal responses.

To be excited by a subject for our own reasons is the only positive precept which should govern our choice. Some painters, such as Canaletto, made subjects out of densely packed incident and detail: others, such as Turner, Seurat and Monet could find equally arresting motifs out of an almost complete absence of 'things' – from empty stretches of sky, sea and field.

But all the great landscape artists have been able to identify some essentially pictorial element in their subjects, however apparently empty. If any precept can be said to apply to subject matter, it lies in this quality of the pictorial, for this is what makes the difference between a subject and a mere view. The subjects of all good landscape paintings have about them a unity the seeds of which existed in nature.

Nature may offer us unity in its clear potentiality for geometrical design, or more elusively in colour or atmosphere, but it does not make these offers altogether invariable: sometimes it will present us with very attractive views whose elements are so scattered, or so equal in emphasis that they almost defy organisation within the limits of a rectangular format. Turner, Seurat and Monet may have painted landscapes with a notable absence of incidentals, but they avoided those in which no element of broad design could be found.

Then there are subjects with pictorial possibilities, but which may bristle with unnoticed difficulties – unnoticed, that is, until the painter is well embarked on his canvas.

It is not that a painter should be advised to avoid

difficulties, but he should be careful to identify them so that he can realise how far he is about to stretch his abilities. An exciting middle distance seen through a gap in a foreground of tangled undergrowth may offer splendid opportunities: but in your excitement with that middle distance, do not fail to notice that perhaps half your painting will have to deal with the undergrowth. Try to see a way forward to resolving this part of the problem, realise how very difficult it may be to make something of, and beware of proceeding with all the easier bits only to discover that you are faced with large passages intractably beyond your powers. We all come up against problems of this sort; if we are determined to solve them, then it is worth taking time to make many careful studies and drawings of undergrowth or whatever, until we discover the underlying structures and can begin to make order out of chaos.

Because nobody should tell a landscape painter what to paint, it is easier to be cautionary than positive about subject matter. Perhaps the only positive advice I would give is that when you look for a subject, in however apparently familiar a countryside, you should find it because in one way or another it takes you by surprise.

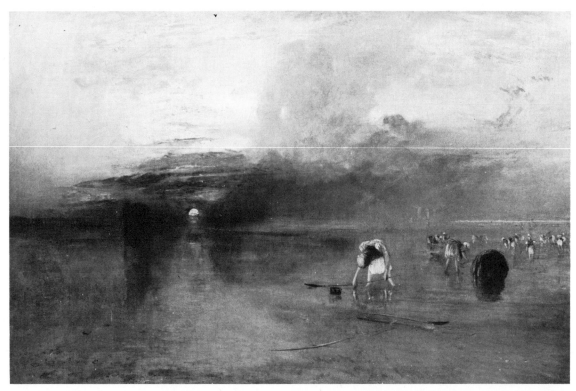

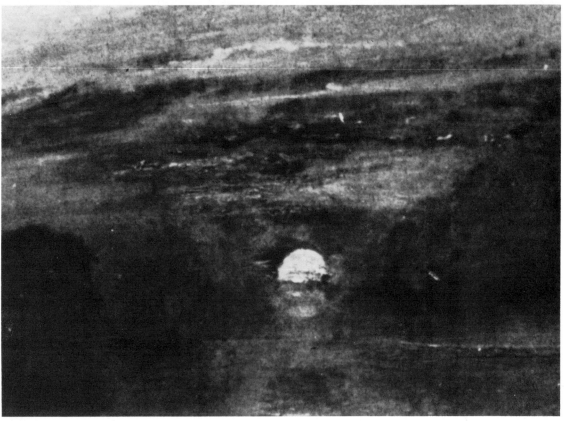

J M W TURNER 1775–1851
Calais Sands, Low Water. Poissards collecting bait
1830
Oil on Canvas 72 cm × 106 cm (28½ in. × 42 in.)
Bury Art Gallery
This famous painting is an example of a design
created from passages of atmospheric tone, generated
by the setting sun. The horizon line is hinted, and
really discovered in terms of the balance between sky
and reflections. The accents of the figures and the
harbour arm punctuate the space and are set well off
centre, not to detract from the essential theme of
light

JOHN CONSTABLE 1776–1837
*Golding Constable's Flower Garden c.*1815.
33 cm × 50 cm (13 in. × 20 in.)
Ipswich Borough Council (Museums)
By comparison with his mature work this scene by
the youthful Constable of his home as an innocent
charm. All the elements are stated with an equally
assiduous intensity: but it was from such close study
in youth that he learnt to select. Already there is a
powerful confidence of design

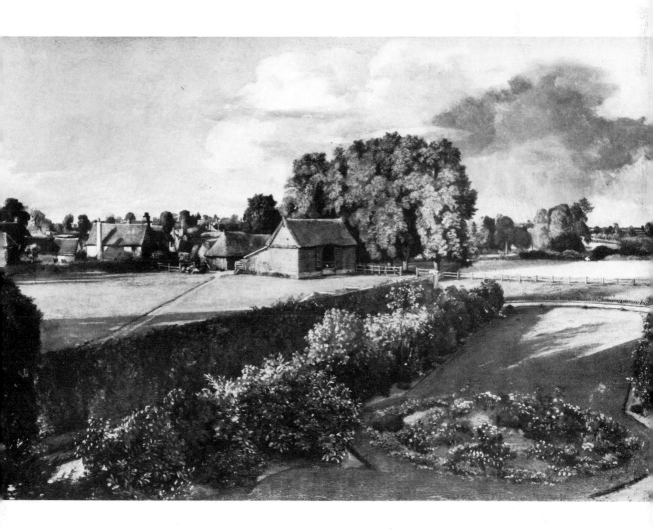

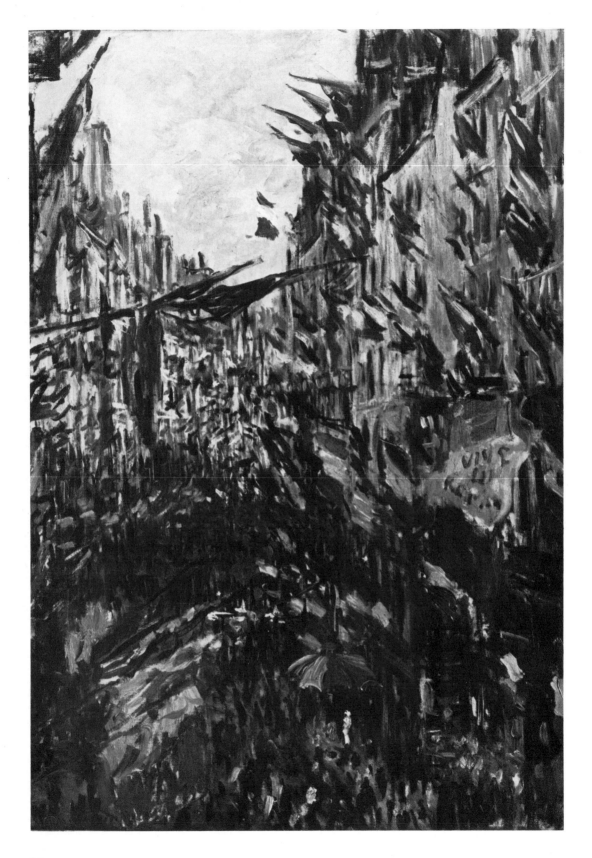

CLAUDE MONET 1840–1926
The Rue Montorguerl decked with flags 1878
Oil on Canvas 61 cm × 33 cm (24¼ in. × 13 in.)
Musée de Rouen
This work shows well how Impressionism was able to
express not only atmosphere but local colour.
Sharply stated contrasts of light and shade tend
towards the exclusion of saturated local colours, and
the expression of these had often been inhibited in
earlier Realists with their inheritance of chiaroscuro.
The Impressionist substitution of colour for darkness
in the depiction of shadow was in this sense a
release. The flags in this painting seem to present
Monet with none of the awkward local colour
problems he had sometimes experienced in his earlier
work; he is able to make them the central theme

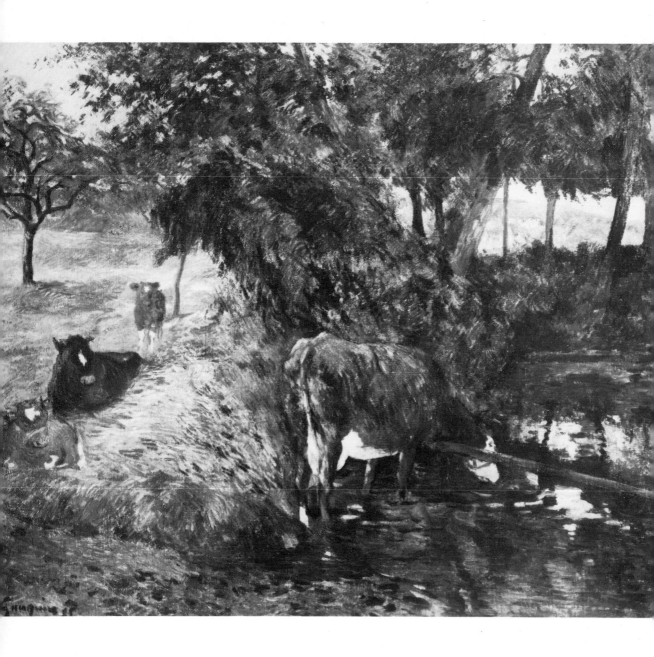

PAUL GAUGUIN 1848–1903
Landscape with cows in an orchard 1885
Oil on Canvas 64 cm × 85 cm (25½ in. × 33½ in.)
Boymans Museum, Rotterdam
Of all the Impressionists, Gauguin was to react most
strongly against the movement. This painting,
however, was made soon after he had been working
with the older Pissarro and reflects his influence. This
landscape might have comprised two separate and
equal views on either side of the central mass of
foliage but they are beautifully linked into a unit by
the movement of the cows, which loops round
bringing the eye to rest in the right foreground.

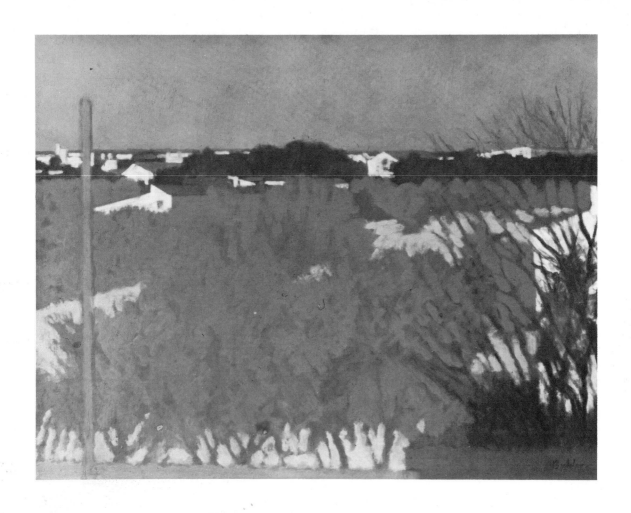

ROBERT BUHLER 1916–
Olive Trees, Algarve 1976
Royal Academy of Arts, London
71 cm × 91 cm (28 in. × 36 in.)
Nature does not always obey the text book. In this
painting the subject has given the artist the
opportunity to gather his darkest and lightest tones
together not in the foreground but in the distance.

The screen of foreground trees is held together
with closely related half-tones, none of which
compete with the distant strip: the spatial sense is
fully given by the finely stated contrast of intervals
and scale. It may be noted that, in this frontal view
of the scene, only a few hints of diagonal perspective
are needed to support the recession and more would
obtrude on the pictorial conception.

Drawing and Design

It is possible to draw a landscape in a way that amounts to a linear record of topographical detail, assembled perhaps in a way that recognizes the feel of the landscape as a whole, but which is unconcerned with recording any sense of illumination.

But when we come to consider the painting of landscape, we will probably recognize that light is an essential part of our response to what we see. It is light in its many moods that plays a large part in unifying foreground and distance, generalities and details, in all their complexity.

This is why (although there can be no simple or single definition of 'drawing') it is wise to approach any preliminary drawing of landscape with a feeling for its ultimate expression of light, whatever form that expression may take.

Some painters, for instance, may start by sweeping in large masses of tone and broad colour suggestions, setting up a soft evocation of mass and light which seems to have little relation to linear drawing. But the matter of decisive placing of masses, then of selection of detail, will raise its head. Then what we may call 'drawing' of the sort relevant to this kind of conception becomes a matter of placing. Detail may be limited or absent; intervals and directions must still be decided upon. It is only too easy for these elements of drawing, if they have not been thought of from the start, to become a succession of imposed disappointments upon a promising luminous beginning.

If a painter chooses to start by a careful rendering of linear detail, with the idea that any further considerations may follow in due course, he will fall equally into the opposite trap. When he comes to the stage of recognizing the existence of light, he may find it impossible to fit this into the rigid linear framework he has already created.

Whatever kind of drawing is initiated, it is likely to lead the painter into rapid difficulties unless from the start it takes into account this basic luminosity, and considers the painting from the point of view of what it is eventually to become.

Of course it is all very well to preach in such general terms, but how can we set about the business of preliminary drawing?

Remember that your painting will be a design, strong or weak, which stems from the interest in the scene which engaged you in the first place. It is a good idea to make a number of quick thumb-nail drawings which will help to clarify in your own mind what this interest really is. These need be for nobody's eyes but your own and need therefore not be made to 'look well', but one of them will strike you as the key to what you want to express. This preliminary drawing is valuable in two ways. It will be something to which you can refer back while you work to remind yourself of your initial enthusiasm. But it will also at the start give you a clue about the approach you will have to make to space and recession and to the sort of drawing which will best help your painting to take off. You will have discovered whether you are most interested in the recessive depth or the landscape with a special focus at some stage in the distance; or on the other hand in the flat pattern which the elements make, with the sense of focus more dispersed. These two kinds of interest are not mutually exclusive, and in fact most good landscape paintings will combine them both. But since they will also usually emphasize one or the other bias, it will be convenient to consider them for a little as extreme points of view.

When the motif of a landscape lies in strong linear perspective recessions such as of roads or rivers, the eye is usually being led to some focal incident. When this is so, then the careful placing of such a focus as a first stage of drawing is all-important, far more than that of detail. There may, of course, be more than one focus, but the placing of the dominant one will determine the disposition of the large masses, (very likely to be recessive triangles converging on the focus). Inexperienced painters will often start drawing the attractive focal subject, church spire or whatever, in what seems an 'important' place on the canvas with little regard to the placing it will enforce on everything else in the painting. But, except by luck, this will be to everything's disadvantage, since the focal points and the receding planes depend upon each other for their combined power of expression.

Take trouble, and make enough preliminary drawings, to

discover where the centre of interest will be best placed so that the large planes of the painting will be best disposed round it. It may be far from the centre of the canvas. The important thing is that the eye be led to the right place in the most expressive way that the surroundings can contribute.

If your motif suggests a more flat overall pattern, and this is what has arrested your attention, then the placing of a particular detail, though important, may play a more subordinate role.

At any rate the demands of linear perspective recession must not initially be allowed to take over. It is the frontal surfaces of the subjects which will be the first consideration. The drawing process should start by enquiry into the way in which the subject suggests a flat geometry of colour values across the canvas. Detail will be 'focussed' in a more subordinate way, but will find its place in punctuating the geometry. It would be absurd to lay down rigid laws about how the drawing marks of landscape should be made. But it may be well to resist the early demands of detail; rather start looking for placings, intervals and large directions. These directions are the lines which link incidents of detail across the canvas so that together they link to form coherent masses. It is very necessary to discover how the large tonal and colour masses make up such directions, for it is such masses that will form the design of the completed work. The kind of drawing which best discovers them, controls them, and thereby initiates a sense of unity to the work cannot be injected as an afterthought.

Remember that in the perception of landscape, the quality of the third dimension is interpreted 'stereoscopically' by binocular vision only in the foreground. The recessions of middle distance to distance are understood by the way our visual senses perceive tone, colour and reductions of scale. Our understanding of a landscape's form may therefore be in a sense more 'intellectual' or more analytical than the understanding of a model of that landscape seen from the same viewpoint. Or at least our optical mechanism has to operate on a more elusive set of clues.

As I have indicated, there can be no prescription for drawing a landscape, especially for that drawing which is to lead into a painting. Nevertheless, a theoretical procedure considered as a kind of mental reference which may help to sort out our thoughts can do no positive harm.

I have suggested that the masses and rhythms of a landscape can be seen as creating a potential geometry of shapes and directions. Within this geometrical framework or the natural abstract design lies a series of silhouettes

denoting facts. They may be solids – woods, groups of buildings or clouds – or tonal phenomena, cast shadows or areas of light. Most likely they will be a mixture of the two. If we think of silhouettes as being made from the edges of the various shapes we can distinguish, then we can begin to sort them out in terms of distances. I do not suggest this as any kind of a rule, but as an aid to clarifying recessions. If we think (at least temporarily) of all that we see as imposed variously on a series of receding transparent backdrops, then we can begin to sort out silhouettes (simply 'shapes', if you prefer) in receding families. Certain sets of shapes will be felt to be on, or near, one particular backdrop. If we were very elementary we would allow ourselves only three such backdrops, foreground, middle distance and distance. But we can be more sophisticated and allow ourselves, say, nine backdrops or twelve backdrops. We could postulate a hundred and twelve of them, but this would clearly be confusing to the point of absurdity.

A little practice will enable us to judge how many backdrops, or stages of distance, we really need in our minds to simplify and yet do justice to what is before us. With the idea that all shapes will collect together on our canvas in a limited number of recessive sets we can begin to find these sets of shapes within the more abstract geometry we have already demarcated or at least felt on the canvas. Facts can begin to be realised in their most expressive places with a sense of comparative distances. Perhaps it does not matter too much which fact comes first. If there is a particular centre of interest, some single element of this might be stated, and everything that can be felt to be on the same 'backdrop' or plane of distance be also indicated. The objects on a substantially nearer or further plane can then be 'silhouetted'. As the surface builds up (I am thinking of this as a linear procedure) with lines round shapes, there will be a good deal of overlapping. If we leave slight gaps between successively receding silhouettes, we shall soon find that we have created a coherent and simplified suggestion of depth from foreground to distance. Of course all this is too theoretical to be a rigid procedure, but let us proceed with the theory for a little.

Between our sets of separate vertical planes (the backdrops) we shall see phenomena which link them to each other in places. Receding roads, wall edges, branches and surface markings will wind their way (also guided by a preliminary abstract framework) from front to rear in 'perspective' giving spatial continuity to what we have already done.

So far we have been thinking in a linear way. Suppose we now consider the tonal masses which have been in suspense since we conceived the first framework. We shall find that

the tones, broadly suggested, will also weave across the linear silhouettes, sharply differentiating them in some passages, merging from front to rear in others. In this way we can begin to link, in counterpoint as it were, a coherent set of tones to a coherent set of shapes, combining to develop a coherent sense of distance.

Now all this is by way of being more theoretical than practical, a way of helping us think. In practice, I must repeat that it is not, for me at any rate, a good idea to let too much line build up on a canvas without the introduction of some statement of tone and colour value. Once lines build up too far, it is possible to find that one is faced with what has become a linear conception; it remains only to convert it not so much into a painting as a coloured drawing. The procedure of sorting distance out into sets of vertical planes is therefore something probably better experimented with on paper as a part of one's preliminary notes. The important thing is that the 'drawing' stage of painting tackles the problem of resolving the mass of visual events into manageable quantities.

It is a feature of oil paint that lines can be wiped out very easily where they are superfluous, and advantage should be taken of this. If your motif is leading you to make a direct rendering of strong light and shade, beware of leaving sharp dark lines of drawing passing through potential areas of deep shadow; it is the nature of deep shadow to reduce sharp accents, and such lines will only impede you when you come to paint these passages. Again, as I have mentioned, some tone values in nature will merge though the forms creating them may be widely separated in distance. A sharp line dividing such similarities of tone will tend to impede and even destroy the sense of openness and separation. Of course on a very flatly conceived painting you may want to do just this, but you should know what you are doing.

Because lines must almost inevitably play some role in the search for design, placing, and realization of shape, but yet can interfere with the development of the painting, it is usually well to draw in a tone which is itself quite light. Some painters like the freedom and flow of charcoal to start a canvas; it is a broad and uninhibiting medium and has the advantage of discouraging a finicky preoccupation with detail at an early stage. But nothing can more quickly impose a network of lines. I find it best to flick off all superfluous charcoal with a cloth until the marks I need are just showing, and then to go over them with a light thin colour such as terre vert reduced in turpentine.

Usually I prefer to dispense with charcoal and start drawing lightly with a brush, since it allows not only line

but some indication of tone to be rubbed in at the earliest stages when necessary. With a brush and pale paint (easily rubbed out) those lines which are to remain lines as part of the substance of the painting can be imposed more emphatically, and in a colour which will incorporate itself in the colour scheme of the painting.

Of course it is possible to start a landscape without any lines: a painter of sufficiently decisive eye for design may place on the canvas directly in terms of tonal and even colour masses. (It is only necessary to look at late Turners to see such linear accents as are needed being discovered during the course of the painting.) Then edges between values take the place of lines: but the same principles hold good – the multiplicity of nature must be sorted out into manageable quantities. Tonal design established by the building up of large masses is drawing in a linear sense at one remove, but it is drawing nevertheless.

If a painting is started in this way, it is best to start thinly (for technical reasons, too), almost like a watercolour, so that areas which turn out to be unhappily placed can be wiped out with as much readiness as they have been put in. There is no reason why shapes conceived in colour values should not be realised as well by 'pushing out' from their centres with tones as by bounding them with lines, so long as we remember that the process does not absolve us from discovering shapes.

Experiment with these different approaches to drawings, and others; no two motifs will demand quite the same kind of beginning. Each approach will have its advantages and its dangers. If you carry drawing to a highly developed stage of linear structure before you start to express values of colour, you may have difficulty in recalling and injecting the broad colour design that you originally intended. But if you can succeed, then each stage of colour development should progressively add to the unity of the painting. If on the other hand you start at the opposite pole with a broad simplified tonal design washed and rubbed in across the canvas then the sense of unity will be there from the start. The attendant danger is that as you progress to more and more particularised statements, this initial unity may become fragmented.

There is no better lesson than to study landscapes by masters and compare them with the kinds of drawings they made for them. There are many such lessons to be found from Rubens, Claude and Poussin to Constable, Turner, Cézanne and Bonnard. They are examples of the way in which drawing may be conceived appropriately in terms of the completed painting.

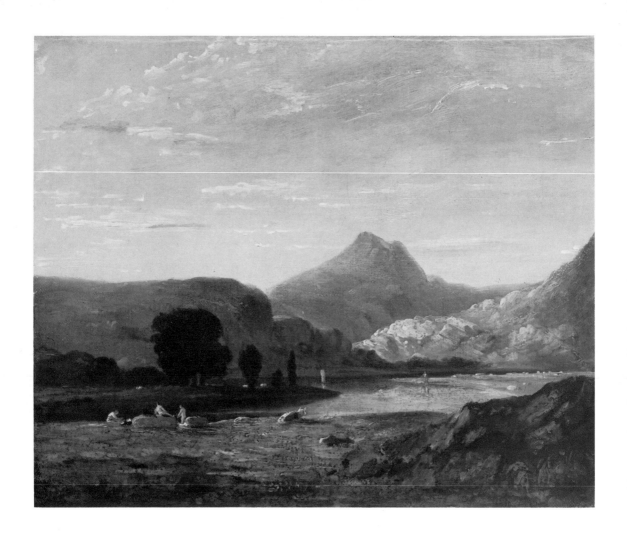

RICHARD WILSON 1713–82
On The Wye
Oil on Canvas 25 cm × 31 cm (10 in. × 12¼ in.)
Tate Gallery, London
Wilson, the first great English landscape painter,
shows the influence of his Italian study more in his
grand sense of placing and design than in the
classical figures which are gathered into its own tonal
mass. In the Claudian way, opposition of light and
dark intervals push the landscape into the distance.
Wilson was perhaps one of the last who would do
full honour to this device; by Constable's day it had
becoming time-worn, and it was he who found an
escape from it.

ALFRED CLINT 1807–1883
Hampstead from the Heath
61 cm × 91 cm (24 in. × 36 in.)
Tate Gallery, London
A landscape carried out with unrelenting detail from
foreground into distance can have a kind of intensity
peculiar to the genre. But only if, as here, it is no less
unrelentingly organized. Formal arrangement may
have its traces cunningly hidden, but without it such
a mass of highly wrought detail is likely to fall into
confusion.

FORD MADOX BROWN 1821–93
Walton on the Naze, 1859–60
Oil on Canvas 31 cm × 42 cm (12¼ in. × 16¼ in.)
Birmingham Museums and Art Gallery
Ford Madox Brown, like the Pre-Raphaelites who
looked to his example, indulged in a 'truth' to
natural detail not always to more recent taste. The
work may be of much artifice; nevertheless the
sustaining of detail through such a range of depth
depends on a remarkable opposition of scale and
sense of interval. It is a lesson to 'detail' painters not
to neglect the foreground, which is here resolved to
its limits

WALTER SICKERT 1860–1942
Statue of Duquesne Dieppe 1902
Oil on Canvas 131 cm × 101 cm (51½ in. × 39¾ in.)
Manchester City Art Gallery
Sickert had been the studio assistant of Whistler, and
enjoyed an artistic upbringing in the company of the
Impressionists. Among his illustrious peers it was
Degas whom he especially revered, and it was the
older master's capacity to paint from drawn studies
that Sickert absorbed. He drew, but seldom painted
on the spot. There could be few better examples to
justify the practice for a realist: Sickert could carry
the authentic sense of outdoor values and immediacy
into the studio with the aid of the copious colour
notes which cover many of his drawings. This
townscape shows how well he could then organise his
experience into a grand design without the pressures
which outdoor painting imposes. Such a method is
time-honoured, but for a realist needs the
development of a practised visual memory.

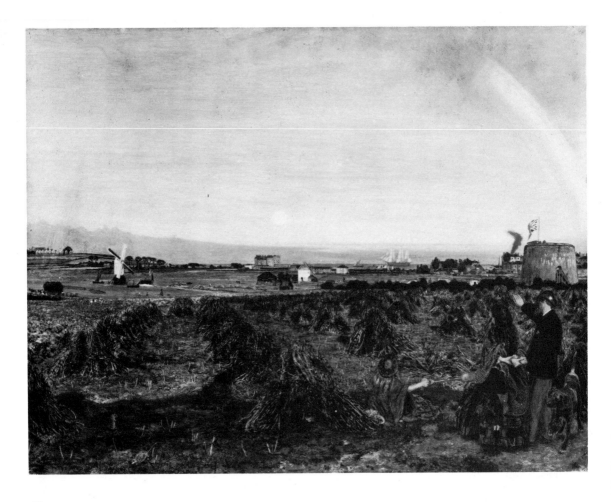

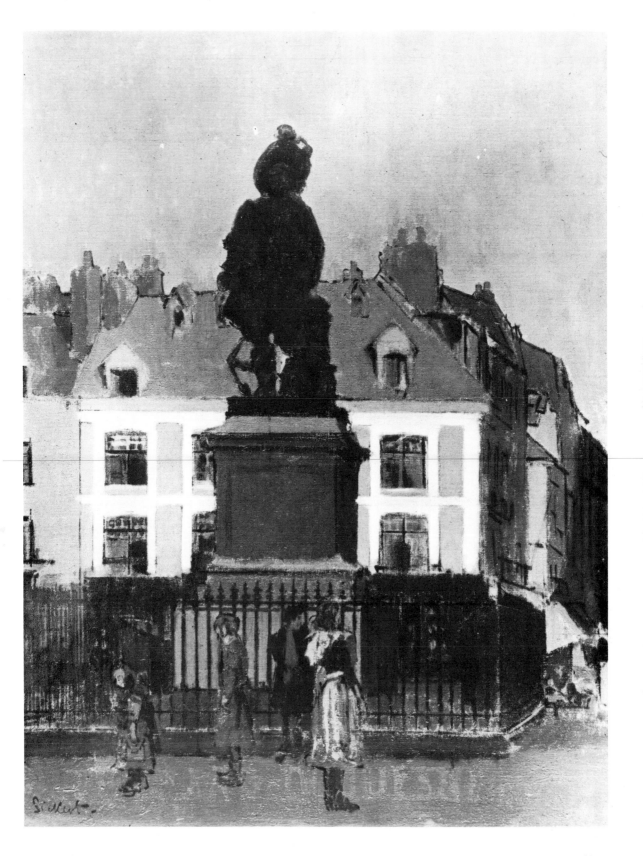

49

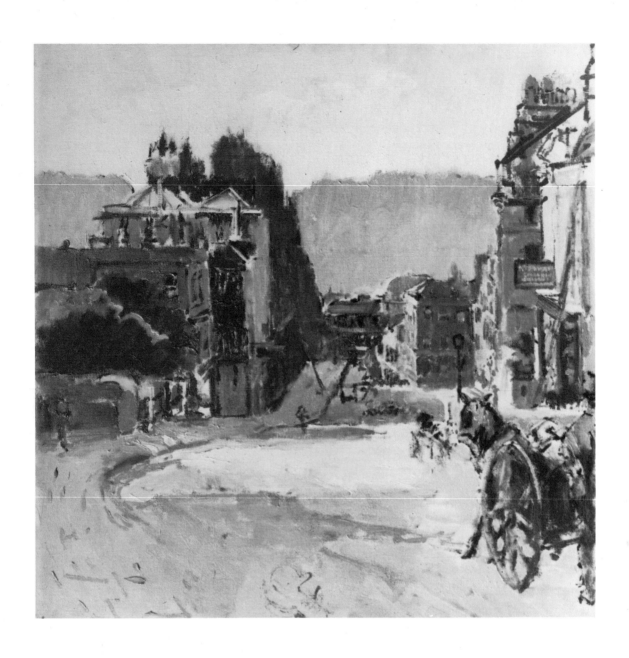

WALTER SICKERT
Belvedere, Bath 1917–18
Oil on Canvas 68 cm × 68 cm (26¾ in. × 27 in.)
Tate Gallery, London
This later painting follows the method of painting
from studies seen in his *Statue of Duquesne*. Sickert
exemplifies well the practice of building a picture
surface from lean to fat paint in an orderly
progression of layers, which he saw as the essence of
la bonne peinture. He likened such a surface to a
pack of cards thrown on a table, so that parts of
each layer may peep through the gaps in those
superimposed on it

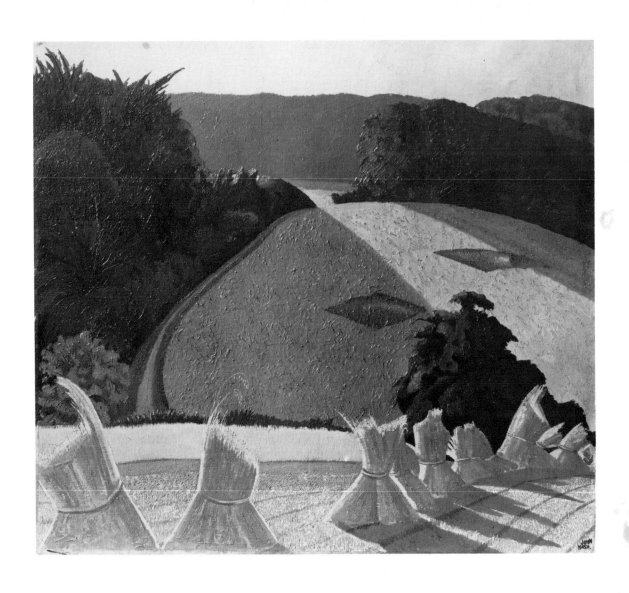

JOHN NASH 1893–1977
The Cornfield, 1918
Oil on Canvas 68 cm × 76 cm (27 in. × 30 in.)
Tate Gallery, London
There is the utmost contrast of characteristic
silhouettes in this deceptively simple rendering; each
element is almost symbolically defined, and the
nature of each part is strengthened by the textural
contrasts of surface. John Nash was a considerable
botanist and understood how a knowledge of
detailed plant forms helps to a resolving of the
general shapes, even though the details themselves
are largely eliminated

The Structure of Atmospheric Recession and Tone

The junctions and separations of forms and surfaces in nature which we are able to represent graphically as lines, are really edges, hard or blurred between differences of illumination and colour. For it is light, and the effect of light on the tones and colours of things, that enables us to see at all.

In landscape, the distances involved also place between the features and ourselves a body of air, humid and dust laden to varying degrees. Thus recession is perceived through successive veils of air to give us that sense of natural landscape distance which is 'atmospheric recession'.

The linear considerations of structure that we have so far looked at allow us to place the receding shapes and positions of landscape features more or less accurately. The result will be a rendering of structure which carries explanation a certain way. But, as we shall see, such a linear structure forms a framework across which light and colour play a deeper role: and it is a role played in counterpoint, for the shapes made by light and colour will pass across the shapes made by line, only sometimes coinciding. It may be pointed out that landscape drawings made purely with lines can convey a sense of light and air, and we have only to look at the drawings of Rembrandt, or among moderns, Bonnard, to see that this is so.

But such apparently linear drawings were made from a great understanding of light: the lines that comprise them are not only measurement marks, but shorthand notations, as it were, of illumination. We shall look at some ways in which line can be made to imply light, but this is part of method, the questions about which we have yet to face. Before we do this, we must see what tone, atmosphere, and colour can tell us about the structure of a landscape, and how they, like linear considerations, can be examined beyond mere surface appearance.

The phenomena of light and colour in a landscape combine to give a unity of visual effect, and we must think of the separate components with due caution; any single one is always modified by the others, and cold-blooded analysis is somewhat artificial. However, for the sake of simplifying complexity, let us take 'atmosphere' first.

The air is, as I have said, a particle laden body whose transparency depends on its condition and its depth. Clouds, for instance, are a specifically visible reversion of the air's transparency, capable of obscuring not only landscape but the sun itself. But even cloudless air always carries a degree of particle substance. The deeper the distance the more air we look through, and the more progressively opaque its substance. On a clear day the transparency through which we see distance is merely reduced: on a heavy day transparency may be reduced to nothing.

The first effect of this reduction is that differences of light and shade, of 'tone' become less and less contrasted through to the distance. A foreground structure of rock may be revealed in a strong contrast of light and shadow. A distant structure of the same sort in the same light will show only a very slight difference of tone between the lights and the darks. The lights may be slightly reduced in relation to the foreground lights, but it is the shadows which will have lost the major part of the contrasting strength: their tone will have moved towards that of the light. Compared to the foreground shadows, the whole tone of the distant rocks will appear light, including the shadows. The reason for this is that the intervening air particles are themselves illuminated and therefore light in tone: it is the shadows that suffer most loss from this veiling. The effect on lit surfaces is more variable. White-washed surfaces in sunlight will probably be lighter in the foreground than in the distance. But the illuminated surface of something very dark and non-reflective in 'local colour' in the foreground, will probably be darker than its distant equivalent. This is because we see a dark surface near to us with very little air in the way. In the distance most of what we see by way of tone is the belt of illuminated air itself.

This kind of atmospheric behaviour generally holds good, but it must not be given the title of a rule. It is possible for eccentric local conditions of atmosphere to confound it: a patch of foreground mist together with distant clear sunlight could reverse the norm.

A second effect of atmospheric depth is on colour. The atmosphere layer not only reduces tonal contrast but has the property of acting as a filter through which cool colours pass while warm colours are held. The blue and violet part

of the spectrum reaches us more readily than the red and yellow.

Because of this we experience the familiar sight of distant blue hills which we may know to be in fact as variegated in colour as the foreground if we get close to them. This cooling off of local colour values and shadow values varies of course with the atmospheric conditions. It is important to notice that this effect, which can be very obvious in the distance also occurs more subtly at intervening depths. Colours four hundred metres/yards away which look very warm seen in themselves, may, compared to the immediate foreground, look not quite so warm after all. This cooling effect, by shifting all values towards blue or cool grey and reducing red and yellow, has also the property of reducing all contrasts of colour.

Thus the very presence of air, by these reductions towards coolness and pale tone, tells us something about distances in landscape and contributes to our understanding of its structure.

Tonal recession: local colour and cloud shadows
Tonal recession in landscape is almost atmospheric recession under another name, but it is perhaps worth defining separately, since tones seem to group themselves together in landscape for other reasons than atmosphere and illumination only. Tones are the various gradations, thought of in the first instance monochromatically from the darkest dark to the lightest light that we can see.

Two things complicate tone. The first is that a surface has a degree of tone not just from the light, but from its own local colour. A black house looks darker than a grey house, if both are at the same distance. But as we have seen, a black house in the distance may seem no darker than a grey house in the foreground.

Thus the way in which we must judge recession by the tones we perceive is not quite so simple as 'atmospheric recession' might make it seem. What we shall have to notice is that though tones of different things at different distances may group together, we shall almost certainly find that there is a difference in their colour values.

A second complication, not always present, is the cast shadow of clouds. Indoors, a subject is normally lit by a restricted source of light which is interrupted only by parts of the subject itself as in a still life. An 'off-stage' obstruction may cast a shadow on the subject, but in a static way. Not always so in landscape.

The landscape painter's source of light is the sky, often the direct sun. The orderly tonal and atmospheric recession of

a sunny landscape may be interrupted by cool bands of darker value laid across it which are the cast shadows of clouds. If they are rare passing clouds on an otherwise clear day, they can be left to pass; but if they characteristically linger, use may be made of them. Alternate bands of illumination and of cloud shadow from foreground to distance can be used to enhance recession. It must be remembered that this was a formal and often artificial device used for this purpose by seventeenth- and eighteenth-century painters; it was generally avoided by the Impressionists. It should be used if it can be observed, not imposed as a trick, and it must be noticed that cast cloud shadows themselves follow the behaviour of atmospherically recessive tones.

J M W TURNER 1775–1851
Venice, The Piazzetta, with the ceremony of the Doge marrying the sea 1835–40
Oil on Canvas 91 cm × 121 cm (36 in. × 47¾ in.)
In many of Turner's Venetian paintings the detail is highly resolved. Here, although the design is laid out by the placing of figures, buildings and boats, detail is suppressed and all is held together by tonal masses playing across the substance

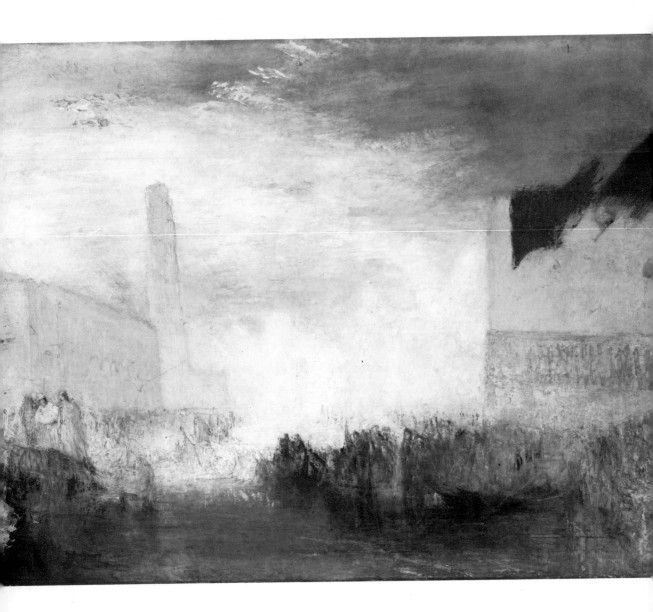

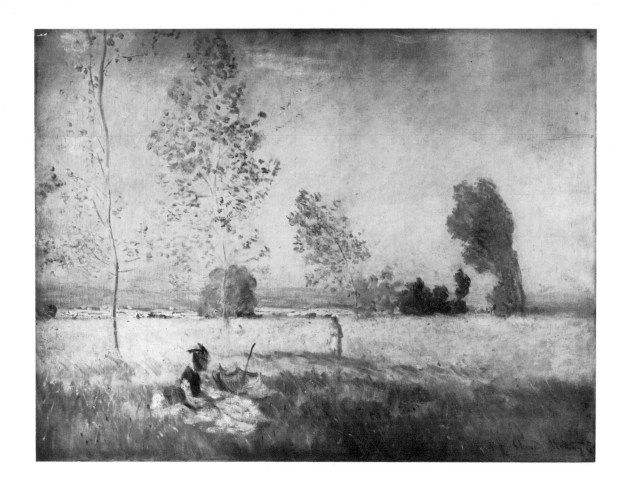

CLAUDE MONET 1840–1926
Les Champs 1874
Oil on Canvas 57 cm × 80 cm (22½ in. × 31½ in.)
Painted in the year of the first Impressionist
Exhibition in Paris, this canvas typifies the ethic of
the movement in its fairly brief period of total self-
confidence. All is submitted to the truth of luminous
atmosphere: from this subordination of form were to
spring the doubts in the minds of the movement's
own adherents. Even Monet, its high priest, was too
strong a draughtsman and designer to disregard
pictorial arrangement; as in this painting, his chosen
viewpoints always manage to produce a forceful
composition

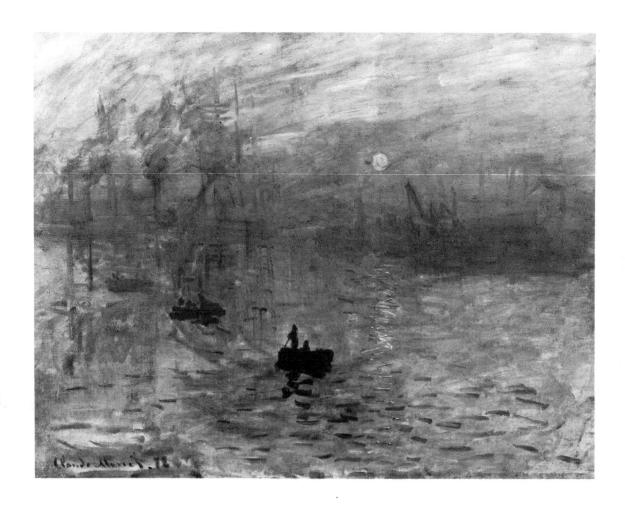

CLAUDE MONET 1840–1926
Impression, Sunrise 1872
Oil on Canvas 49 cm × 65 cm (19½ in. × 25½ in.)
Musée Marmottan, Paris
This is the painting whose title gave currency to the
initially derisive term 'Impressionism'. It has affinities
with Turner, whose work Monet had seen in
London. Indeed there is a small gouache by Turner,
painted over forty years earlier, which startlingly
anticipates this work both in subject and expression.

Yet Turner's brilliant observation was habitually
ordered by a grand, if eccentric pictorial conception:
Monet has in this canvas reached a point where
direct visual experience could take virtual control of
the surface

GEORGES SEURAT 1859–91
Courbevoie Bridge 1886–7
Oil on Canvas 45 cm × 54 cm (18 in. × 21½ in.)
Courtauld Institute, London
Camille Pissarro described Seurat's 'pointillism' as
scientific impression. The superiority of Seurat's
work over that of his followers suggests that his
achievement was as much the result of sensibility as
of his pretensions to have created a scientific system
of painting. The method, based on prevalent theories
of colour, did not entirely meet its claims, and
perhaps it succeeds most in its effect of irridescent
atmosphere. The quality of this canvas lies in
Seurat's power of containing his system within a
classic sense of interval and balance. Pointillism had
an attendant virtue. The painstaking method made
slick lines impossible: Seurat's landscapes are
characterized by the careful searching of forms and
edges

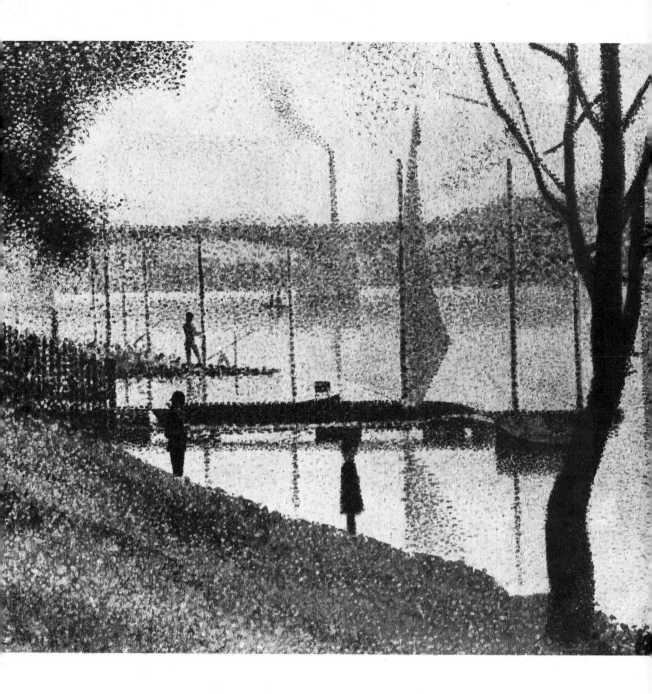

SPENCER GORE 1878–1914
Panshanger Park c.1909
Oil on Canvas 50 cm × 61 cm (20 in. × 24 in.)
Royal Albert Memorial Museum, Exeter
Gore, like his Camden Town associate Gilman, was in
a broad sense an English heir of 'Neo-Impressionism'.
As in a late Pissarro this painting uses a restrained
divisionism to control what could have been
confused. A *sous-bois* such as this, with its close up
views of trunks, branches and twigs, can easily turn
into a maze of aimlessly wandering lines which soon
convert the subject from the inviting to the
intractable. Gore avoids this pitfall with mastery. The
obvious linear elements, so dangerously easy to latch
on to, are all ordered by what lies between. It repays
study of this work to see how every branch combines
with another to enclose a coherent space. The tonal
masses are as much drawn and designed as the
branch forms and all is blended into a unity. The
painting is such a natural response to the subject that
it is worth looking at the plate upside down to
appreciate how broadly the artist has grasped
nature's design

Sky: Structure and Light

The sky presents a problem which, though not unique to landscape painting, is characteristic of it. In interior painting, windows and light sources sometimes present passages which are many times higher in tone than anything else, but it is a choice of the artist to face himself with such motifs. In landscape, the sky is frequently, perhaps usually, many times higher in tone than the landscape beneath it, but this will be a fact that the landscape painter cannot usually avoid facing. Of course it is not always so; in conditions of very brilliant sunlight, or of lowering clouds, landscape elements of light surface may be illuminated to a higher tone. Sometimes a view of the sky may be eliminated altogether.

But it will be a general and recurring problem of landscape that the tone of a sky compared to the tone of ground values will present a range far greater than can be matched with white and black paint on the palette. I have already discussed the problem of re-organising the tones of nature into what the palette can manage. It holds good of most indoor tonal subjects, but in landscape the range will characteristically be extreme.

So perhaps one of the first matters the landscape painter must consider is that he cannot be literal about the tone of a sky: he must reduce it because in most cases he has no alternative. This means inventing: a way must be found, through colour, of implying the sky's luminosity.

There is a factor common to the elements of sky in most landscape paintings which makes this not so impossible as it seems. The sky is the landscape's source of light. It is often erroneously assumed that therefore the part of a sky which appears on a canvas is the source of light. This is in fact very seldom so (there is an exception which I shall come to). The visible arc of the sky is anything up to 180°. That part of the sky which appears in a painting is unlikely

to be more than 20° to 30° of this arc from the skyline. Whether on a sunlit or on a cloudy day, by far the greatest part of the illumination will be coming from that part of the sky which is out of the painting. So the inevitable reduction of tone of a 'picture-sky' is not really so inconsistent with natural luminosity; it is a very minor source of light. On a sunny day, the sun itself is of course the main source, the rest of the sky supplying the half-tones to surfaces turned from the sun. Only when we are facing onto a low sun, painting *contre-jour*, does the picture-sky become a main light source. In these circumstances the painter is even further in his resources from the tonal range of nature. He must arrive at an equivalent to nature by responding to the way in which such brilliant light reduces nearly all the accents and contrasts on the ground in an aura of shadowy tone, from which the illuminated edges of forms will spring as exceptional tonal events. Indeed the main accents might be found in cloud-screens. This was a recurring motif of Turner.

But either in *contre-jour* subjects or in those where, as normally, the source of light is outside the canvas, it is of the greatest importance that the sky be felt as part of the design of the painting. This is true both in a linear sense and in colour, and is certainly one of the more difficult problems of landscape.

As to colour, it is only too easy (because in nature it often seems at first sight to be so) to make the colour of a painted sky divorced from the colour of everything else. A blue sky seems so very blue when everything else seems green and yellow and red. This is all the more reason for not treating the sky as a separate colour problem. The sky, after all, is visibly illuminated atmosphere, and this atmosphere is what we breathe. It does not end on the skyline. If we think of the sky as something which reaches to our toes as we paint, enveloping the whole landscape, then we can begin to feel towards a total relationship of colour.

A blue sky will give 'blueness' or coolness to some facets of the terrain, and it is not evenly blue all over. It will change its own colour character from the skyline upwards toward the zenith, perhaps from violet through ochre to green-blue to red-blue, or some equivalent change. Its juxtaposition to the varied colours of the skyline will impose apparent shifts to its own colour. 'Windows' of sky seen through gaps will vary considerably in colour.

From these shifts of value it will always be possible to find common qualities between sky and ground, and it is well to keep the developing colour of each working together. If you detect, say, a greenness in some part of a

sky, look to see what greens exist on the ground, and try introducing a paler version of some of this in touches in the sky area – so with reds, yellows, violets and other colours. You may be surprised to find just how far a convincing blue sky, which is not just an imitative coloured back-drop but is part of the picture, can be built out of the hints from the colours of the whole subject; a very little blue out of the tube may go a long way. Perhaps no painter built skies out of the total colour of his subject more convincingly than Cézanne.

In a concern with colour, it must not be forgotten that the sky, like the earth, has structure: sometimes it is elusive, sometimes clouds make it very apparent. I will not dwell on the meteorological nature of different cloud formations (Constable devoted much study to this), but a little observation of varied weather shows how often the sky will present its structure as a receding surface seen from underneath, with its own perspective. It is not too difficult to see, in certain conditions, how banks of cloud reduce in scale into the distance, with a successive overlapping, like an inverted landscape. But look hard and you will see how often these cloud formations, although constantly altering in size and position, will respond to a vanishing point on the horizon.

The sky's structure therefore has a subtle duality. As colour, its atmospheric composition envelops everything, and conditions or modifies the colour of everything. But beyond highly varying limits of transparency it becomes a soft and semi-opaque recessive surface in which linear properties can be detected. When, between the ground surface and this semi-opacity, the atmosphere condenses into identifiable cloud forms then the linear properties are greatly clarified. Of course, the sky's opacity is relative. If it were fully opaque we would live in perpetual darkness; it is its high but varying degree of transparency which enables sunlight to strike through.

Remember that the sun is so far away that its rays are parallel; when the rays of the setting sun seem to splay out in diagonals through cloud gaps it is because we are seeing parallel lines in perspective. Remember also that the colour of the sky immediately above the sky-line is frequently (and increasingly) conditioned by man-made 'smog'. This may envelop everything, or may sometimes be identified as a wall of colour over a distant urban area, from which the immediate landscape is comparatively free.

Most important, have in mind always that sky has properties of colour and structure which allow it to be translated in paint as part of the total picture.

J M W TURNER 1775–1851

*Thames near Walton Bridge c.*1807

Oil on panel 371 cm × 731 cm (14⅝ in. × 29 in.)

Tate Gallery, London

Turner's set pieces of classical mythology and marine
drama were informed in their conception of
landscape not merely by the stylistic conventions of
older masters, but by an assiduous and unceasing
study of nature. This is one such study, in which
Turner seems akin to Constable in his reaction to
visual experience. The outdoor tones are reduced to a
small, carefully adjusted range of warm and cool
values. The linear intervals and directions are
expressively disposed in the format, and it may be
noted that the sky, though freely painted, is as
carefully designed as the ground features

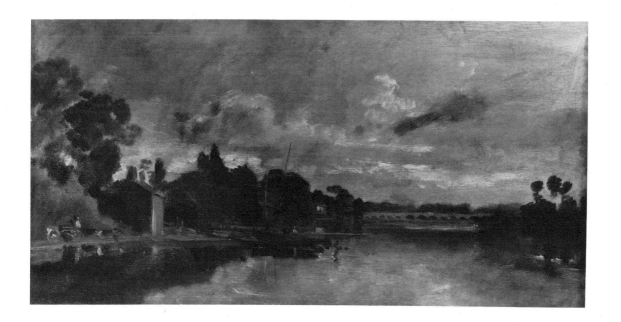

JOHN CONSTABLE 1776–1937
Sky study
Victoria and Albert Museum, London
Landscape paintings are commonly seen in which the
'sky' is a mere backdrop to the subject. Constable
understood how the sky has its own many forms and
substances with every turn of wind and weather, and
perhaps no painter has made such a deep study of
these forms. This is one of many sky studies he made
throughout his life

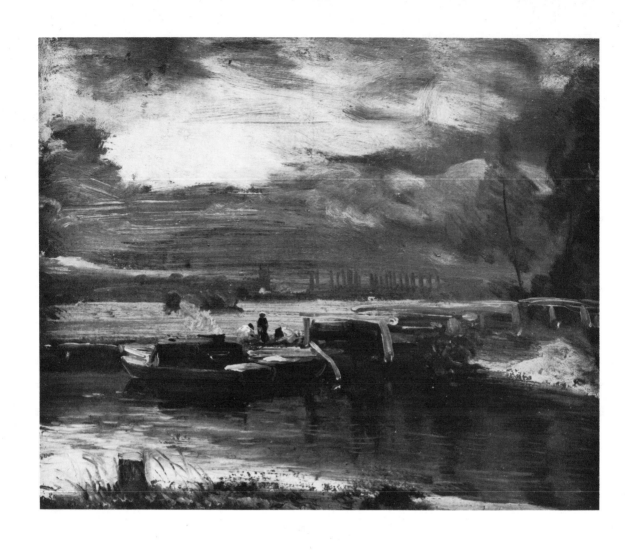

JOHN CONSTABLE 1776–1837
*Barges on the Stour c.*1811
Oil on paper 26 cm × 31 cm ($10\frac{1}{4}$ × $12\frac{1}{4}$ in.)
Victoria and Albert Museum, London
This brilliant sketch shows how Constable, like
Cézanne after him, could evoke reality out of a few
broad oppositions of warm and cool values. The
blues and whites are swept across a golden umber
ground: a few darker and lighter accents are enough
to suggest the material substance of the forms

CLAUDE MONET 1840–1926
View of Zaandam 1871
Oil on Canvas 45 cm × 72 cm (18 in. × 28 in.)
Louvre, Paris
Although painted a little before the term came into
use this canvas may properly be called Impressionist.
While it does not employ the full fragmentation of
colour developed shortly afterwards by Monet
himself, together with Renoir, it has the
characteristics which distinguish it from earlier
realism.

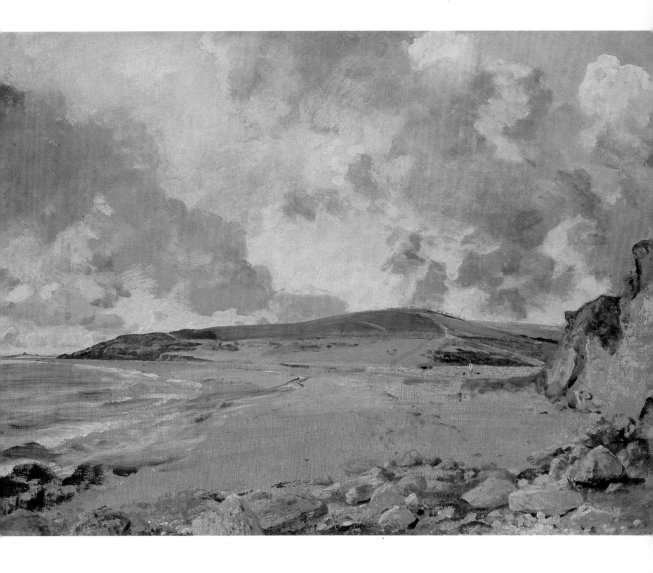

JOHN CONSTABLE 1776-1837
Weymouth Bay 1816
Oil on canvas 53 cm x 75 cm (21 in. x 29½ in.)
National Gallery, London
Of this well known painting it needs to be reiterated that a
master of landscape can realise all the separate colours
and lively characteristics of sky, land and water, and yet by
a chromatic and compositional organisation combine all
these elements into a pictorial unity of surface

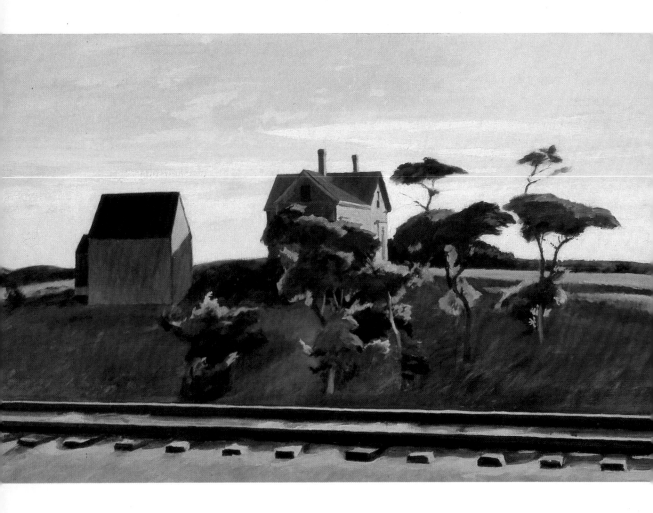

EDWARD HOPPER 1882-1967
New York, New Haven and Hartford 1931
Oil on canvas 81 cm x 127 cm (32 in. x 50 in.)
Indianapolis Museum of Art,
Emma Harter Sweetser Fund
This most impressive of American landscape painters was
adept at evoking the strongest sense of place out of the
simplest elements. The embankment, the farm buildings
with their one strong accent of colour, the rail road tracks
striking across the foreground, combine to make a symbol
of isolation without any sentimentality. Behind the
harshness of style lies pictorial sensibility. A lesser artist
might have made much of the departing perspective of the
rail sleepers to establish the foreground plane. It is enough
for Hopper simply to hint at it, so preserving the overall
sense of chromatic silhouette

Colour

Colour should not be thought of as an entity separate from structure, tone and atmosphere, or as a problem in landscape painting which can in some way be considered at a later stage when matters of structure and tone have been settled, a factor to be imposed as a self-contained stage in the process of painting.

Colour is rather the full amplification of tonality. The colours that we see are the united results of the tints of surfaces ('local colours'), of light, and of atmosphere: this unity we may call 'colour value'. Colour values are the perceived colours of surfaces in their spatial positions. A yellow house in the foreground may be painted with the same 'brand' tint of exterior wall paint as another in the distance, but what we see will not be defined by the label on this tin; differences of distance, of angle to the source of light, and of surrounding colours, will make each house a different colour value. What is true of two yellow houses is also true of a single one. The yellow on the shadowed parts of a house will not be that of the sunlit parts. When the sun goes in both yellows will change. So colour is not a simple matter of decoration. Because it is modified by the direction of surfaces (that is, by forms) in relation to light, colour can in itself become the revealer and explainer of forms and light.

It is sometimes supposed that nothing can be learnt about pictorial colour, and that some are just born with a better 'sense of colour' than others. The latter may or may not be true, but there is no doubt that there are things that can be learnt about colour behaviour which should inform rather than harm any natural gifts which exist. The landscape painter can learn much from quite simple study of the colour he perceives. Codified 'scientific', psychological and mystical theories of colour have been successively propounded over the last two hundred years and more; some elements of them have made contributions to the

development of painting, but probably few painters have been dependent on a deep adherence to any one of them. (Even Kandinsky is hardly an exception to this, since he propounded his own colour theory.)

Perhaps the first characteristic of colour behaviour that a painter, (particularly a landscape painter) should understand is the way in which light sorts colour into 'warm' and 'cool' values. This is a matter of perception, not just a theoretical system, and it is a natural phenomenon which has been a traditional basis for organizing and simplifying colour in painting.

The landscape painter can very readily notice nature demonstrating this. Let us take the example of a sunlit evening landscape. A late sun usually throws a warm light on surfaces which face it so that all these surfaces, irrespective of their local colours, move towards orange, red and yellow – that is, towards 'warmth'. Indeed this condition will clarify for the painter just which surfaces are facing towards the sun, and therefore have to some degree a common aspect.

Surfaces facing away from the sun are of several kinds. We may expect that many of them will be facing a blue or 'cool' sky. We may think of these surfaces as 'in shadow', but in fact they are illuminated by a light source which moves all their values towards blue, violet and 'cold' green, that is towards 'coolness'. Then there are deeper shadows in caves of form where there is a greater absence of illumination. These may be lit by reflections partly from warm surfaces, partly from cool surfaces and will shift accordingly. Some surfaces facing the sun have cast shadows from other forms thrown across them and will be cool in the shadow areas, warm in the illuminated ones. There will be surfaces which turn gradually out of the sun's view and which will often shift to a marked apparent coolness or blue quality just where the form turns away because here it is in closest proximity to the warmth of the sunlit facet. As such surfaces turn right away from the sun their coolness may be given some interior shift back to warmth by reflections from sunlit areas. In very bright sunlight these 'reflected lights' can be dramatic; it must be observed, however, that these reflections are never really as bright or as warm as the sunlit areas which cause them.

We see that all surfaces have their 'local colours' affected according to their particular aspect or position in relation to the source of light, and that in a broad way all these various conditions of form and illumination may be sorted out into those colour values which are warm and those which are cool. Of course, natural appearances do not often make all this as simple as it sounds. In landscapes of

exceptional aridity, in deserts for instance, where there are few contrasts of local colour, the contrasts of warm and cool may be sharply displayed and easy to 'read'; lusher scenes with man-made elements will in practice present us with values whose positions in the warm to cool range are difficult to define, and many such middle values will exist. Nevertheless it may be true to say that a painting which becomes dominated by values which cannot be defined as either warm or cool is likely to end up confused and muddy in colour, however bright the tints of the paint.

The landscapes of both old and modern masters provide ample evidence of how a painting may be designed, not only in terms of tonal masses but of warm and cool masses as well, one or the other usually dominating.

Colours also respond to and influence one another when they are simply thought of as tints of paint on a flat surface. All colours will tend to shift in apparent value when placed in different contexts; bright colours will especially alter the values of duller and more reduced colours when they are placed in juxtaposition. This effect is known as 'simultaneous contrast', and the best possible way in which to find out how colours behave towards each other in this way is by personal experiment. If you place on a canvas several separate strokes of a muted grey and surround each with a different bright colour you will see that each grey apparently alters its value; each in fact will take on some of the opposite or complementary value to the bright colour next to it. Thus orange will give the grey a blue tinge, yellow will give it a violet tinge, and blue will give it a warm orange tinge. If you are trying this experiment for the first time you will be surprised at the extent of these apparent alterations; it can be difficult to believe that the strokes of grey are really all the same tint. It is not only greys and very neutral values that are influenced in this way; all values are to some extent mutually dependent when they are placed in juxtaposition, and much frustration can be avoided if this is understood. You may wish to respond to a passage in a landscape with a particular luminous grey which seems just the equivalent to your vision of nature when you put it down on the canvas. Half an hour later it may be transformed into lifeless mud by the brighter colours you have assembled round it. Quite strongly saturated tints will often have their values shifted by juxtaposition.

This is one of the main reasons why the colours in a painting must always be considered together, and related to each other; the colours will affect each other in any case, so this may as well be in ways that the painter wants. Just as a simple large relationship of linear proportion can be used as

a measure of the proportions to follow, so it is possible to create some measure of colour values by stating two or three strong and closely placed tints on the canvas as soon as the development of the painting allows it.

I do not suggest this as any kind of necessary method – hard and fast systems should be looked on with suspicion – but as one way of providing a 'yardstick' against which following values may be judged. If from such a measure a series of colour values is built up, each relating to what has already been developed, a stage may be reached where the necessary value of a particular passage becomes in a sense inevitable, that is to say, the preceding colours will dictate what it must be.

The process of colour development must of course depend in detail on the way the painting as a whole is conceived and developed. There may be good reason for resolving a particular object or related group of objects to a high degree of completion before much else work is done. The painter should only be deterred from a heterodox attack upon his landscape subject if he feels he cannot thereafter control the course of the work; certainly he should not be deterred by orthodox rules. But in most cases he will be wise to make sure that the colour he initiates provides at least a strong clue to what should follow. Colour needs controlling as much as any other attribute of painting.

It may seem over-simple to say that uncontrolled colour is often due to too many different colours. Yet landscape painting seems to suffer peculiarly from the temptation of the inexperienced to use every available colour on the palette. In order to gain a sense of control over the colour scheme of a painting, it is almost certainly best for the student to start with a simple palette, perhaps of no more than five or six colours. This means working in a restrained key (most of the masters started in this way), but it also compels the painter to discover equivalents for the colours of nature instead of trying to imitate them. We work with paint, not with rainbows, and although clever artists of *trompe l'oeil* may give the effect of having imitated nature, literal imitation is impossible. Introduce new colours onto your palette when you cannot do without them, rather than in order to find a use for them. Experience will enable you to keep control of a progressively wider and more brilliant colour range.

The old adage that light excludes colour often puzzles beginners; but it is particularly important for the landscape painter, who is working under the strongest of light conditions, to understand what it implies.

Since we are considering landscape, let us assume that the source of light, directly or otherwise, is the sun. Now very

brilliant mid-day sunlight will not only emphasize light and shade but will reduce the contrasts between local colours. (It has been said of the tropical sun at noon that 'it puts the colours to sleep'.) In these conditions tonal contrast will be at its maximum, while the differences of the local tints of separate objects will tend to be at their minimum. Even the direct light of sun gradually loses this power as it sinks towards evening, when tonal contrast becomes reduced and local colour (even if warmed up) begins to assert itself. This is much more apparent on a bright grey day, where the flatter and softer light will largely exclude cast shadows and will allow objects even in the middle distance to display their differences of local colour to the maximum. Beyond a certain distance, of course, the unifying effect of atmosphere will enforce its own reduction of colour contrasts.

All this means that the painter should be wary of trying to combine very strong contrasts of light and shade with equally strong contrasts of local colour. A brilliant light source may emphasize one colour, but in nature it is usually at the expense of the other. A combination of heavy 'chiaroscuro' and a multiplicity of bright colours is an invitation to a contradictory harshness of effect. Some early Monet landscapes seem to succeed in this combination, but even in these there is a harshness which we do not find in his more truly Impressionist work which followed. Landscape painters such as Matisse and the Fauves, and Bonnard, working in a high colour key, may be seen to follow the Impressionists in substituting colours for dark tones in rendering shadows.

However, this adage that light excludes colour, remains an adage, not a rule; the best way for the individual to test its truth for himself is by experiment.

It is very difficult to discuss the question of colour without seeming to impose rules: I must emphasize that I do not suggest that there is any particular 'right' way of setting about the development of colour in a landscape painting. While I have said that it may be a good idea to start by stating one or two strong relationships of colour, the examples of 'Pointillism' and 'Divisionism' point to a quite different approach. The development of colour in a Seurat landscape is an almost infinitely subtle combination of 'system' and sensibility: we can see perhaps more clearly in a follower such as Signac or Luce that it is possible to assemble with small marks all the properties of one colour, say, red, that the different elements of a landscape share. Interposed may follow marks showing all the properties of blue, yellow, green and so on, until a luminous network of values emerges where each surface contains in its juxtaposed marks some colour quality of all its neighbours.

This is a crude simplification of a subtle process, and it is certainly not a process which absolves the painter from the need for control. Pointillism is not the language which will suit many, but some exercise in it can be very revealing about the inter-relationships of landscape colour.

The painter should be on guard against over-equality in a painting's colour balance. Equal amounts of warm and cool and equal amounts of strong local colours will make a work seem indecisive. It is very well to discover, like the Impressionists and their followers that the colour of a shadow contains the complementary of a colour in the light. But direct complementaries, stated as strongly as the major colours which are supposed to generate them, can be dangerous and likewise lead to a look of indecision. Even the brightest tints can cancel each other out if none is given any dominance.

Conceive the colour design of your landscape as much as you conceive its linear and tonal composition. Colour may be a matter of mood, but mood must find concrete form in paint.

Perspective

Perspective systems have been invented to codify various
ways in which the third dimension can be expressed and
read on a flat surface. All perspective systems are
distortions of visual perception. The reason for this is that
we do not perceive upon a flat surface. If you imagine
that you are tracing what you see in front of you in depth
on a sheet of glass from a fixed eye-point, then it is clear
that the sheet must be also fixed at right angles to your line
of vision both horizontally and vertically. But it can only
be truly 'normal' to your line of vision at one point;
everywhere else you will be seeing through the glass at an
inclined angle which is ever steeper towards its edges. This
does not matter very much if you are only tracing what is
nearly in front of you, in other words you are restricting
yourself to a narrow angle of vision. But as you look
further round or up and down it will be clear that to go on
tracing an almost true linear image you will have to shift
the glass sheet to preserve its frontality. An infinitely large
number of infinitely small sheets, each oriented to be at
right angles to the line of vision, and all joined together,
would form the concave interior surface of a sphere. It is
upon such a 'sphere of vision' that we actually perceive,
and it is an axiom that a spherical surface cannot be bent,
twisted, stretched or compressed into a planar or flat
surface without distortion. It is important for a
draughtsman to understand that no form of perspective
abolishes distortion, but only systematizes it.

'Central Perspective' is a system largely adopted by
European 'realist' painters, because within reasonable limits
of vision it most nearly projects onto a flat surface our
natural perception.

The base of Central Perspective is the Horizon line. The
viewer selects one point on this Horizon (his own
horizontal level) which is the Centre of Vision. He assumes

that everything else that his sweep of vision includes can be seen in sharp focus. The system propounds that all parallel lines in nature converge on the flat to common Vanishing Points will be at some appropriate level above the Vanishing Points will be on the Horizon. If they slope upwards in nature away from the viewer, their Vanishing Points will be at some appropriate level above the Horizon; if they slope downwards, below the Horizon. The exception is any set of parallel lines which is both horizontal and 'flat on', or at right angles to the Line of Vision (leading to the Centre of Vision). These are assumed to remain horizontal on the drawing surface. In its simplest form this is often known as 'One Point' perspective.

This assumes that if we are looking flat on at a rectangular house, the side of the house will 'vanish' to the Vanishing Point, while the facing wall will remain horizontal.

But since, if we can see the side wall, we cannot be truly facing the front wall 'flat on', there is an inconsistency here. The more visually sophisticated 'Two Point' perspective recognizes this and assumes that if a wall on the left is receding to one Vanishing Point, then the wall on the right must be receding to another. Normally in Central Perspective, vertical lines are assumed to remain vertical in a drawing: but sometimes the view, up a tower or down a shaft, is so elevated that this assumption evidently is in contradiction with the visual evidence. We then have the development of 'Three Point' perspective, in which the vertical lines of nature converge upwards or downwards, as the case may be, to their own Vanishing Points. These Vanishing Points will usually lie outside the limits of the painting or drawing, as indeed those of Two Point perspective will frequently do also. There exists a fairly elaborate system of overcoming this problem by constructing within the picture limits in order to discover what the convergences should be, but the landscape artist will do better to learn how to estimate the necessary slopes to external Vanishing Points by eye: what matters is that a direction should look right for the structural needs of the painting, not that it should conform to the demands of a geometrical system.

In fact if we were to follow Two or Three Point perspective always to its logical conclusion we should continually come up against distortion and inconsistency in relation to Natural Vision.

For instance, if we were to face the opposite facade of a wide street of identical terraced houses, and then started drawing the departing view to the left in Two Point perspective we would find the departing horizontals converging off to the left. Similarly those on the right

would converge to the right. If we then produced these lines to the middle, they would all meet in shallow points (except on the Horizon Line). But clearly in fact they are all continuous straight directions. We must either revert to One Point perspective in order to say so, or abandon the rules and represent these continuities as shallow curves.

The next problem we shall consider is the matter of equal intervals departing in depth. Consider a flat plain surface covered in a rectangular grid like a giant chess board. We can see that the departing intervals become narrower and narrower. It would be a long-winded thing to try to measure all these different gaps by eye, and in fact if we estimate by eye as nearly as we can the ratio of width to depth of the nearest square in the picture surface, seen in perspective, then the rest can be found with the use of Vanishing Points. This depends on the fact that the diagonals running through the squares of a grid system will themselves form two sets of parallel lines, vanishing to left and right points.

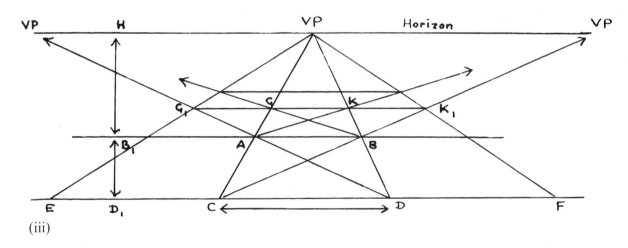

(iii)

Supposing that you are actually looking at a flat horizontal chessboard landscape so that one side of the grid is at right angles to your line of vision, then one set of square-sides will all remain parallel to the horizon; the others will all vanish to a point on the horizon at your Centre of Vision. Now if you take a square which will be in the foreground of your picture, and measure carefully the ratio between its nearer and further side, and between the further side and the horizon, this can then be transferred to your picture. In diagram (iii) this is shown as the vertical proportion $D_1B_1:B_1H$. Then the proportion between the depth and width of the square must be as carefully estimated by eye $(D_1B_1:CD)$. When the square ABCD has been established

in perspective in the picture then mark off on CD produced points EF to the left and right respectively so that EC = CD = DF. You now have the nearer widths of the squares to each side of your first square. Join E and F to the Vanishing Point. Draw diagonals DA and CB, producing them to the horizon to form two more Vanishing Points. These lines will cut through EVP and FVP respectively, and where they cut at G_1 and K_1 will be the interval for your next square backwards in depth. The diagonals of the square ABGK will provide the interval for the next square, and so on towards the horizon. I have already referred in chapter I to the way in which a line of poles diminishes into the distance. The point is easily demonstrated in this chessboard diagram by raising verticals from the departing corners of the squares. If you extend this perspective chessboard too far into the foreground, or too far to either side, its inherent distortions become apparent.

Circles Unless these are seen flat on, they appear in Central Perspective as ellipses. To find the ratio and tilt of an ellipse representing a circle (arches, clock faces and so on), draw first in perspective the square in which it can be thought to lie. (A circle can be inscribed in a square so that the centre of each side is tangental to the circle; this remains true in perspective.) The ratio of an ellipse is the ratio between its major and minor axis, that is, its longest and shortest diameter. Find the perspective centres of each side of the square: these will be the tangential points. From the perspective centre of the square (discovered by drawing the diagonals), draw a line out in perspective as if it were a spindle piercing the square at right angles. This line is the minor axis of the ellipse. From the points where it cuts the square divide this in half. The half-way point is the centre of the ellipse, which is always nearer to you than the perspective centre of the square (diagram iv). Draw another at right angles (not in perspective) to the minor axis, and you have the major axis. The limits of these axes will be discovered as you proceed to inscribe an ellipse. Practise doing this 'free-hand'. Remember that the widest limit of the ellipse will be along the line of the major axis, even though it will not touch the square at either end. The ellipse only touches the square tangentially at the four half-way points of the sides. There are methods of constructing ellipses from axial proportions, but it is better, and the result livelier, if you can learn to make them by eye. By far the most important factor in getting an ellipse to look like a circle lying in its own plane in perspective is to get the directions of the axes right. If you do not do this, the circles will appear to be falling backwards or forwards.

(iv)

If you meet a Gothic Arch, realise that in its simplest form it is made from the arcs of two circles cutting each other (diagram iv).

These are but the simplest devices of Central Perspective. Many more elaborate methods exist for constructing curves, various polyhedrons and so on. But I think that there will be few problems the artist will meet which cannot be worked out from first principles, combined with intelligent observation. Perspective systems are perhaps of their best value in helping the artist to understand the problems of structure he meets: they should not be a substitute for understanding, nor impose their rules on expressive need.

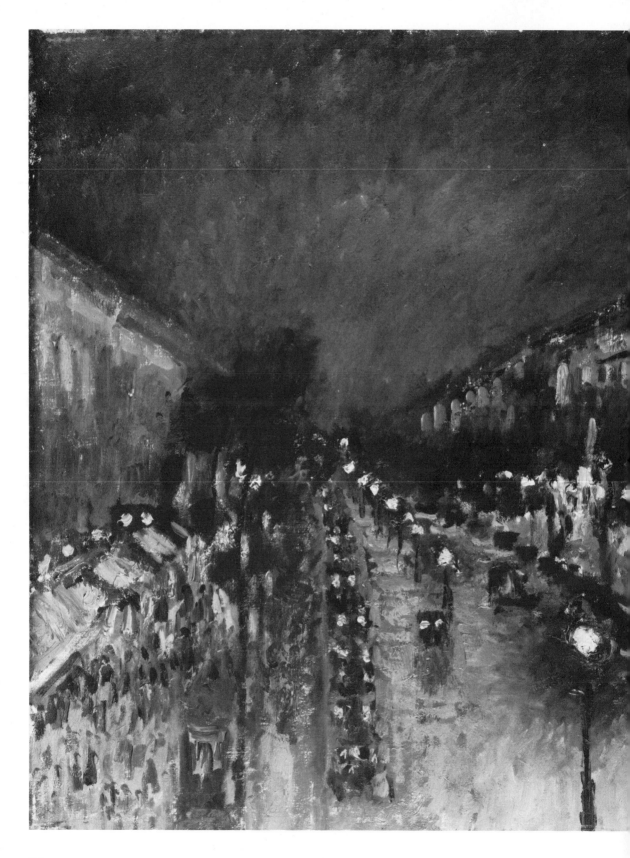

CAMILLE PISSARRO 1831–1903
Boulevard Montmartre 1897
Oil on Canvas 54 cm × 65 cm (21$\frac{1}{4}$ in. × 25$\frac{1}{2}$ in.)
National Gallery, London
Pissarro developed his art in terms of a deep and solid
understanding of the countryside, but was no less
able to transfer his sensibilities to the urban scene.
This is a piece of direct observation, painted from his
hotel window

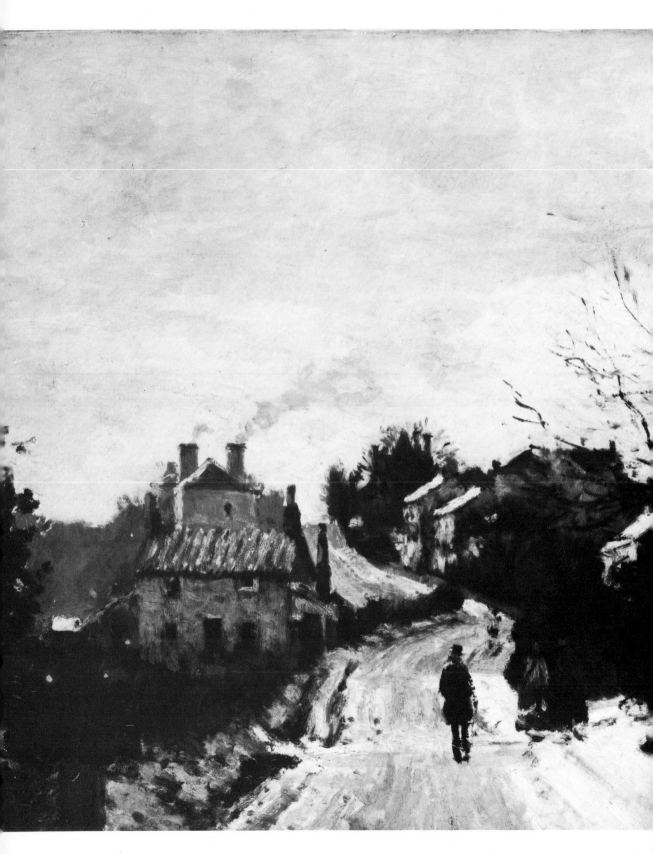

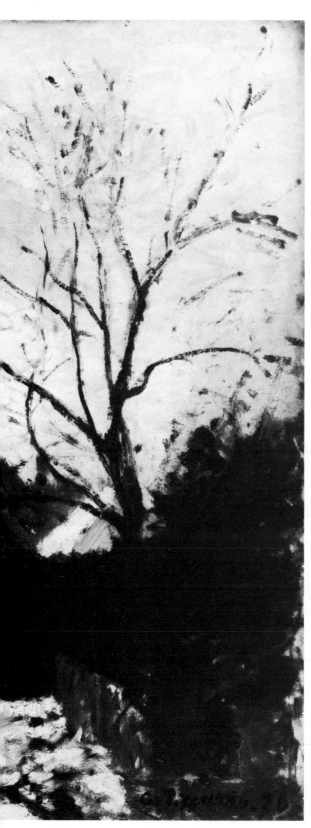

CAMILLE PISSARRO 1831–1903
Lower Norwood 1870
Oil on Canvas 35 cm × 45 cm (13$\frac{7}{8}$ in. × 18 in.)
National Gallery, London
The big contrasts between the static and the active
give this painting its sense of variety, and this is
where its exactness lies. Detail here would be
obtrusive: but in his use of the paint Pissarro shows
the difference between the vital equivalents which he
discovers and the mere sketchiness which he avoids

VINCENT VAN GOGH 1853–90
Populierenlaan bij Neunen
Oil on Canvas 78 cm × 97.5 cm (30¾ in. × 38¾ in.)
Boymans Museum, Rotterdam
This early Van Gogh was painted before he came
under the influence of Provençal light: he is still here
employing the chiaroscuro of the Realist period. The
focus is on the steeple and the figures grouped under
it in the foreground: the perspective Vanishing Point
of the path lies outside the picture to the right, and
does not distract from the centrality of the scene

ANDRÉ DERAIN 1880–1954
The Pool of London 1906
Oil on Canvas 63 cm × 99 cm (25 in. × 39 in.)
Tate Gallery, London © by ADAGP, Paris 1980
Derain's Fauve period paintings, of which this is an
example, lack the subtlety of Matisse, but in their
more rudimentary colour constitute a simpler visual
manifesto of Fauve art. The two dominant bright
local colours, red and blue, also double respectively
as light and shade, while the reserved half-tones of
nature are heightened into greens and violets to meet
the key of the dominants. The viewpoint of Thames
shipping is chosen (as so often in Fauve painting) to
produce the maximum of raked diagonal shapes with
the necessary vigour of graphic movement to contain
the violent colour

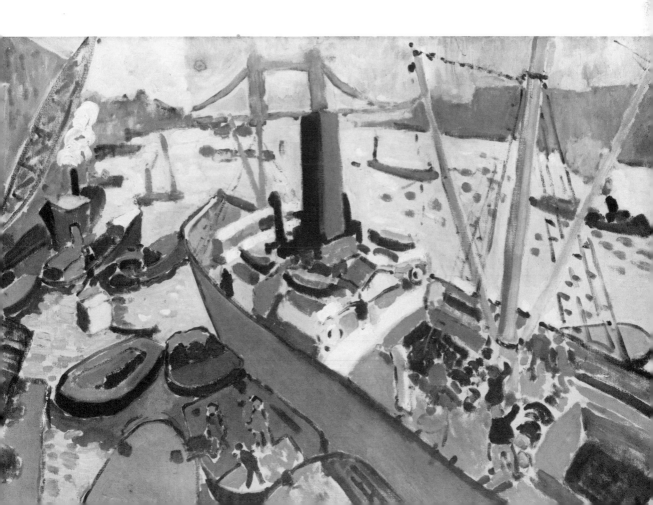

Symbol and Expression

If symbols may seem of little direct relevance to the art of perception, yet their characteristics should not be altogether overlooked by the representational landscape painter.

The word 'symbol' derives from a Greek word meaning a token. We often use it so loosely that its meaning in art becomes confused, but we may perhaps most simply understand a visual symbol as being a shape conveying an idea or message to those with access to the necessary code. Symbolism is an instrument for recognition, however esoterically it may be used. Symbols may hide their meaning to all but a small and select circle, but yet be clear to that circle. Such have been many religious, magic and cult symbols. Other symbols convey their meaning as widely as possible to all. Such, usually, have been those of heraldry, science and urban signs.

Some form of symbols are abstract – squares, circles, bars sinister and so on, and have only a coincidental bearing on the representation of observed forms. But other symbols, whatever their import, are themselves representational; and it is their nature to be instantly recognizable. Symbolic forms of a man, a horse, a tree, a leaf or any familiar shape must show them in a simple way which reveals their characteristic silhouettes as clearly as possible. The front view of a man, the side of a horse, the top view of a moth, are in turn the most immediate revelations of each form: the successful symbol requires a kind of perceptual appreciation of each form's typical aspect.

So there is a lesson from symbolic art even for the perceptual landscape painter.

Trees, for instance, however different individually, have within their types characteristics which distinguish them from other types. Oaks greatly vary, just like men and horses, but they never look like ashes or chestnuts or pines. Each tree, however individual, is a potential symbol of its

own family: this is particularly relevant when we consider the problems of distance unique to landscape. The objects in an interior, whether still-life or figures, will reveal something of their identity readily enough with their details as well as with their general shapes. But details are soon lost in landscape distance: the artist who wishes to reveal the identity of an oak or a beech a mile away must discover the equivalent of an oak or beech symbol to explain them. It is in fact a good test of drawing shapes and forms always to ponder on the most characteristically revealed aspect of a particular object; it is an especially good test for a landscape painter. How can this test be applied in practice?

Let us stay with the example of trees, since they are both a recurring feature of landscape and fortunately in most cases present a similar characteristic shape from any horizontal direction: they do not have back views and side views.

They are made of trunks, branches, twigs and leaves, and when they are close up we can if we choose describe their total forms with paint as a sum of these details. We may omit some details, emphasize others, but we need not substitute some generalized equivalent or a formalized sign to convey the image of an oak tree with leaves.

We can actually count and draw as many perceived leaves and twigs as will imply the others.

But in the middle distance we can no longer count leaves, indeed we cannot see separate leaves, although knowledge tells us they are there. Our expression of the tree must now use different means. 'Pure' symbolism is not usually concerned with the problem of explaining space: where we find subject paintings whose purpose is symbolic narrative (as in many Indian miniatures) then we will often see the distant tree explained by its having fewer leaf shapes than a foreground one. This kind of explanation which symbolically uses some typical element of a form like a leaf to identify it, is appropriate in a painting whose intention or pictorial is that of symbols. It is right in the Indian miniature; it also seems altogether valid in the Douanier Rousseau, and in that late series of Matisse interiors where views through windows show trees expressed in just such a way.

But as landscape painting approaches the expression of perceived and directly experienced realism, this method of symbolizing things which in fact distance makes imperceptible, becomes less and less appropriate.

In the language of realism we should be cautious of enumerating on canvas what we cannot visually count. We may still in a sense 'symbolize' but we must look for explanatory symbols which distance itself provides.

The oak leaf and twig disappear, but they are replaced by a visible clump made up of themselves. This clump is still typical of an oak tree; we can still cling to its 'oaky' nature no less than to that of a single leaf, and the expression of the trees is now to be discovered from the totality of these clump shapes.

Similarly in the far distance even these clumps become indiscernible; we must find the shape which immediately expresses the whole oak tree, and which makes it yet different from other trees. The realist must employ a kind of symbolism in reverse. For him, a single leaf will not stand duty for a distant tree; yet the total shape he finds to express that tree must in some degree symbolise the leaves of which it is made. Landscapes by such masters as Rembrandt and Constable had not perhaps a direct symbolic purpose; yet how well could their drawings of trees be used as symbols, such is the expressive clarity of their shapes.

I have defined symbolism very crudely: but sometimes the term is used to cover almost any departure from direct visual experience, and it should not be so over-worked as to deprive it of meaning. The landscape painter may find himself moving far from the 'facts' in ways that are matters of expressive mood rather than symbolic necessity. The 'Fauve' painters are examples. Although historically some of their adherents may have had associations with French Symbolism, the characteristic invention of heightened colour and dynamically simplified drawing in Fauve painting arises out of the need to express visual mood in the face of visual experience: the inventions are not essentially those of literary symbolic reference. The Fauves were referred to in their time as 'frenzied Impressionists'.

Of course since it is impossible to imitate nature literally, all painters have to invent equivalents, and the possibilities of heightening and altering objective facts are so limitless as to defy category. Attempts to codify expression are usually codifications of school and style. There is a Venetian 'School'; the young Turner modelled himself often in his landscapes on Claude's style. Yet two painters could hardly have been further apart expressively than Veronese and Tintoretto, while in Turner's most 'Claudian' landscapes there is a sense of disturbance at an opposite pole from the French master.

If the possibility of expressive alteration of the visual world is so limitless and so idiosyncratic, can anything much be said about it to help the landscape painter? Perhaps not much: Matisse complained that his attempts to teach ended in his pupils demanding rules for self-expression which he could not give them.